Introduction

Just what is a veteran? Someone once said that a veteran is "A person who wrote a blank check to the government for a value up to and including his life." That is a fairly accurate statement; however, I feel that the check I wrote was to the American people and not necessarily to the government. I say that because I never did wholly agree with all of the policies of my leaders. Like a good soldier though I followed the lawful orders of those appointed over me for 21 years.

Veterans, be they male or female, are a special breed of people. They joined an organization much bigger than they were and that organization demanded every ounce of them no matter what from day one. From the inception of this country we have called on those willing to serve first to create our nation and later to preserve it and its values. Those willing to don the uniform and do so honorably are truly heroes, whether they served in combat or not. They were all willing to make the ultimate sacrifice for freedom.

The face of the United States veteran has changed over the years. In some eras those faces were covered with facial hair while serving and more recently not. In many cases those faces have always been male and most recently we have begun to see females. The one thing that has not changed in the United States service member is a willingness to get the job done no

matter the cost. Service members swear an oath and live by a code. They possess qualities like courage and honor hidden deep within their souls that can never truly be understood by those who have never served.

This project was born to honor those who served and continue to serve. It was born of a desire to give back to those who have given so much and to call attention to the face next to you in the mall. As you can see from the variety of faces on these pages, the small woman standing next to you may have, at one time, put her life on the line so you can enjoy your day of shopping. Remember that the next time a stranger needs help. He may not be homeless due to his choices; he may be homeless due to his sacrifices.

If you have never had the privilege and honor to wear the uniform, remember these words and the courage it takes to utter them as you flip through these pages:

The Commissioning Oath

"I, _____ , having been appointed an officer in the (Service) of the United States, as indicated above in the grade of _____ do solemnly swear that I will support and defend the Constitution of the United States against all enemies, foreign or domestic, that I will bear true faith and allegiance to the same; that I take this obligation freely, without any mental reservations or purpose of evasion; and that I will well and faithfully

discharge the duties of the office upon which I am about to enter; So help me God."

The Enlistment Oath

"I, _____, do solemnly swear that I will support and defend the Constitution of the United States against all enemies, foreign and domestic; that I will bear true faith and allegiance to the same; and that I will obey the orders of the President of the United States and the orders of the officers appointed over me, according to regulations and the Uniform Code of Military Justice. So help me God."

A little about the brotherhood of veterans and service members is appropriate here. First I would like to say that the term brotherhood automatically extends to our female comrades who have worn and do wear the uniform with pride, honor, and dignity. In the world of the veteran there is no male and female, only veterans. Secondly being in the military forms bonds that often span lifetimes. No matter if you were in combat or not, military service has filled you with good memories and often supplied you with good friends. Bonds formed in combat are the strongest bonds. It is impossible to face death with others and not bond with them on the most intimate of levels.

I hope this book accomplishes something that not many have been done in the past. I hope that it draws attention to the

service and sacrifice of those who wear and have worn the nation's uniform. It is also important to note what I mean about serving during a war. If your years of service indicate to me that you were in the military during a war, whether or not you deployed, you served during that war. This book is about the sacrifice of the veteran and includes sacrifices that happened and those who were prepared to sacrifice it all. I have tried hard to exclude no one in this, the first volume of this book.

The Saint Crispin's Day Speech

Henry V

William Shakespeare

"This day is called the Feast of Crispian.
He that outlives this day and comes safe home
Will stand a-tiptoe when this day is named
And rouse him at the name of Crispian.
He that shall see this day and live t' old age
Will yearly on the vigil feast his neighbours
And say, "Tomorrow is Saint Crispian."
Then will he strip his sleeve and show his scars
And say, "These wounds I had on Crispin's day."
Old men forget; yet all shall be forgot,
But he'll remember, with advantages
What feats he did that day. Then shall our names,
Familiar in his mouth as household words —
Harry the King, Bedford and Exeter,
Warwick and Talbot, Salisbury and Gloucester —
Be in their flowing cups freshly remembered.
This story shall the good man teach his son,
And Crispin Crispian shall ne'er go by
From this day to the ending of the world,
But we in it shall be remembered,
We few, we happy few, we band of brothers.
For he today that sheds his blood with me
Shall be my brother; be he ne'er so vile,

This day shall gentle his condition.
And gentlemen in England now abed
Shall think themselves accursed they were not here,
And hold their manhoods cheap whiles any speaks
That fought with us upon Saint Crispian's Day."

"When I go to war I want the whiskey drinkers. You can keep the milk drinkers."

- Stanley A Mozak
Master Sergeant (Retired), Unite States Air Force

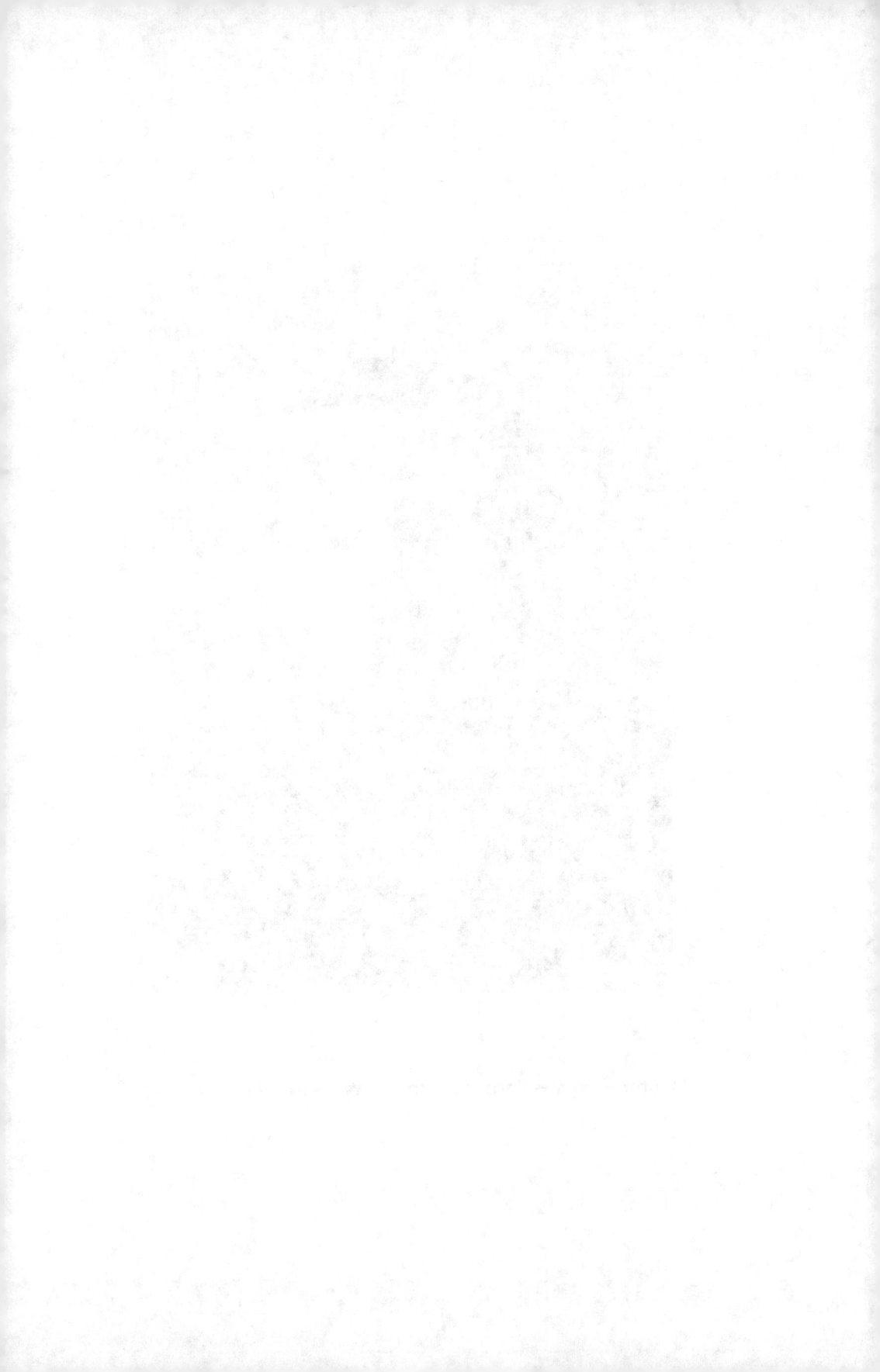

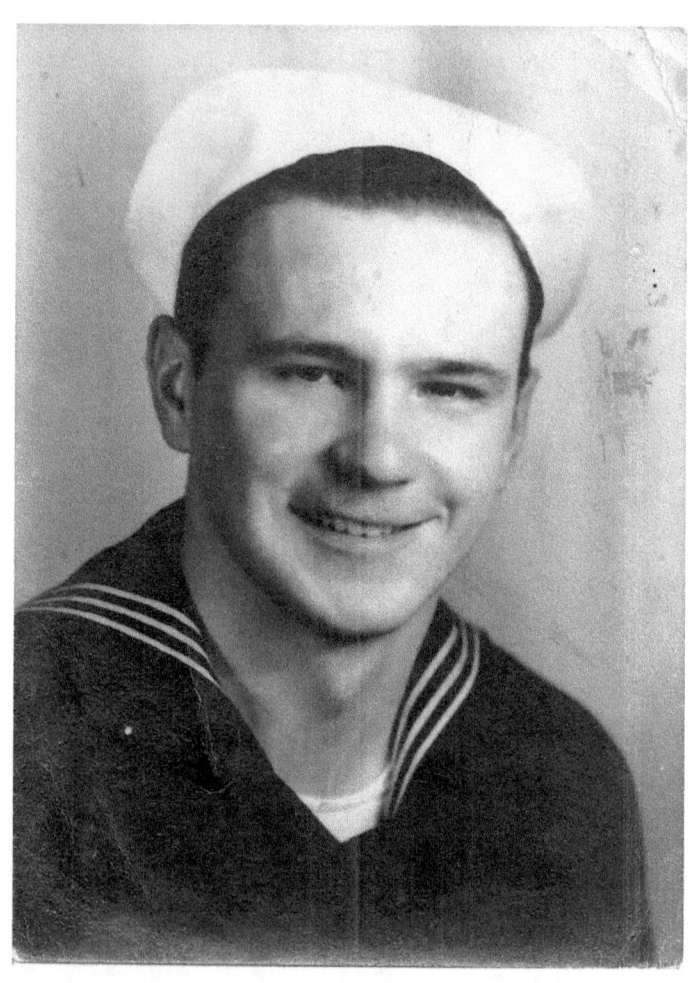

Walter – Navy – Torpedoman – WWII – My Dad, My Hero

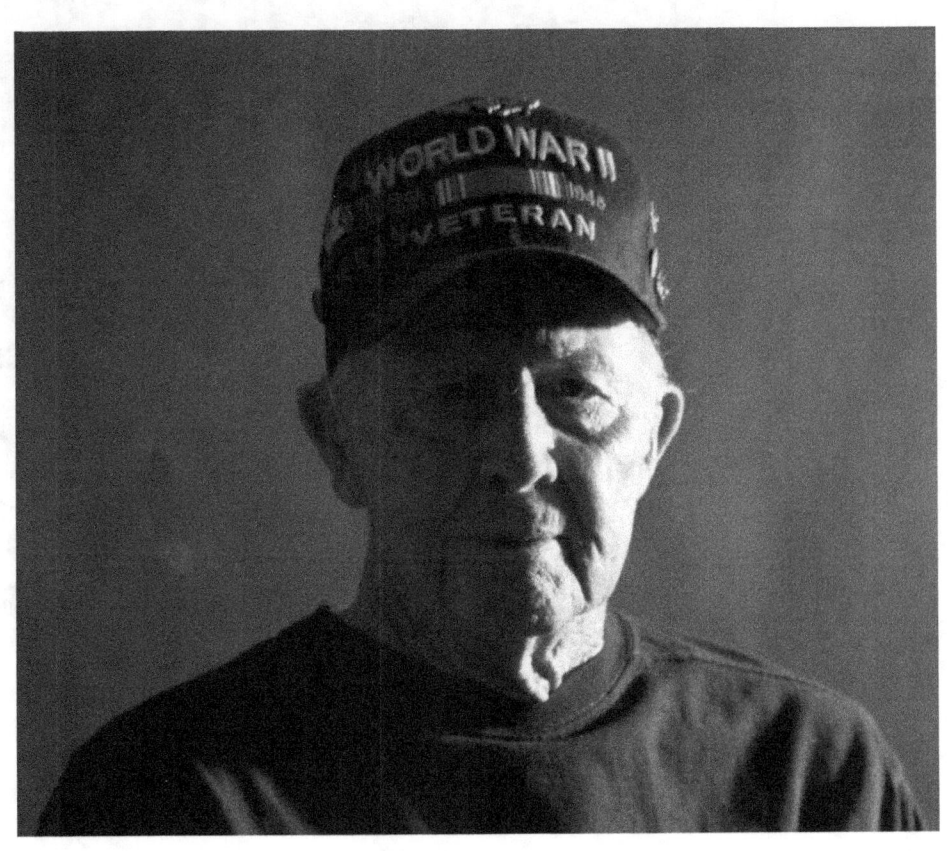

Earl – Army Air Corps and Air Force – WWII, Berlin Airlift, Korea, Vietnam

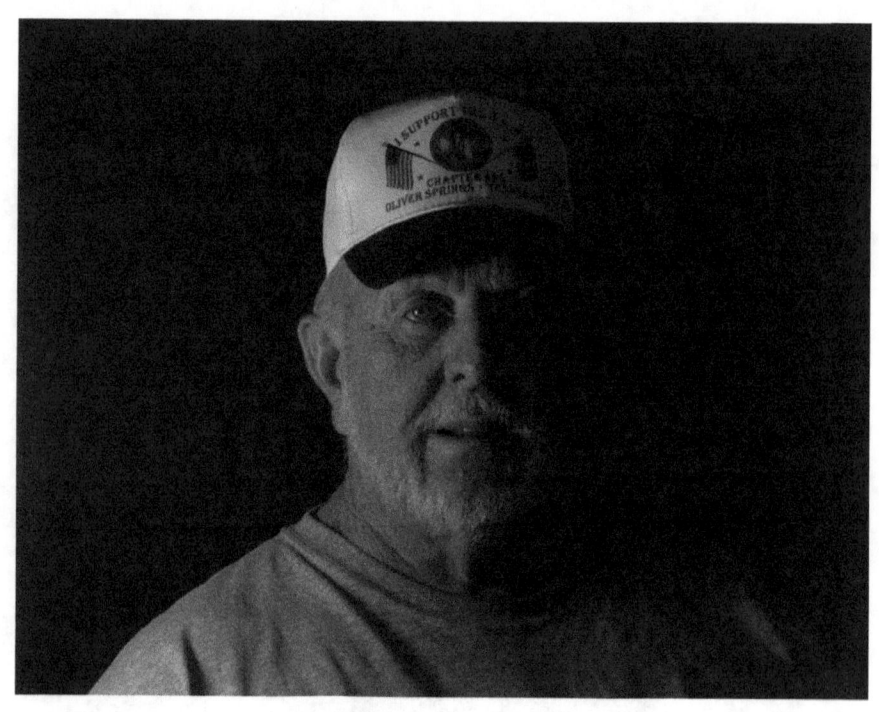

Charlie – Army – Supply Specialist – Vietnam

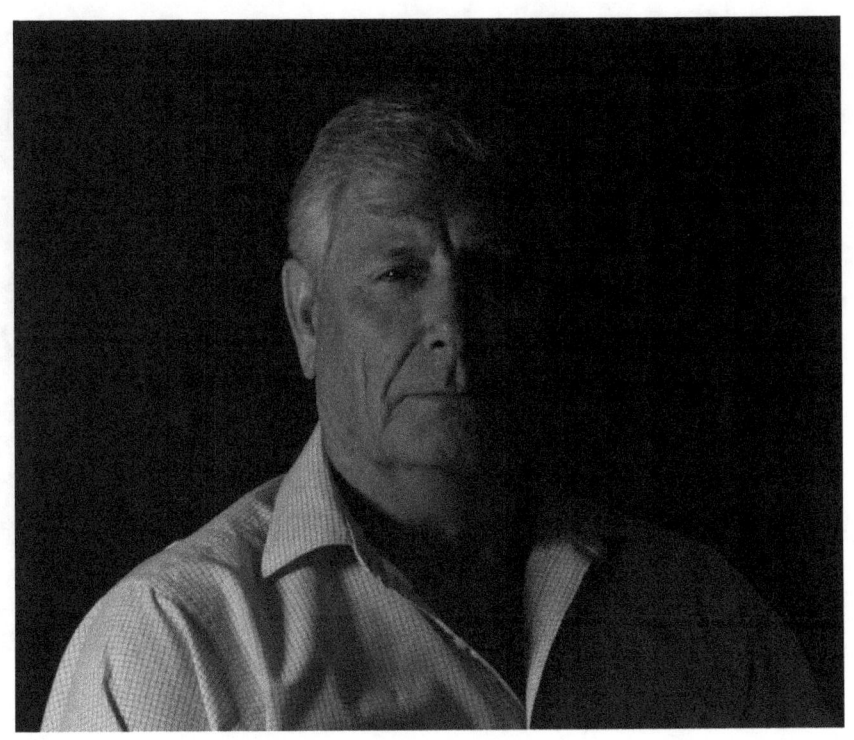

Dennis – Army – Combat Engineer – Vietnam

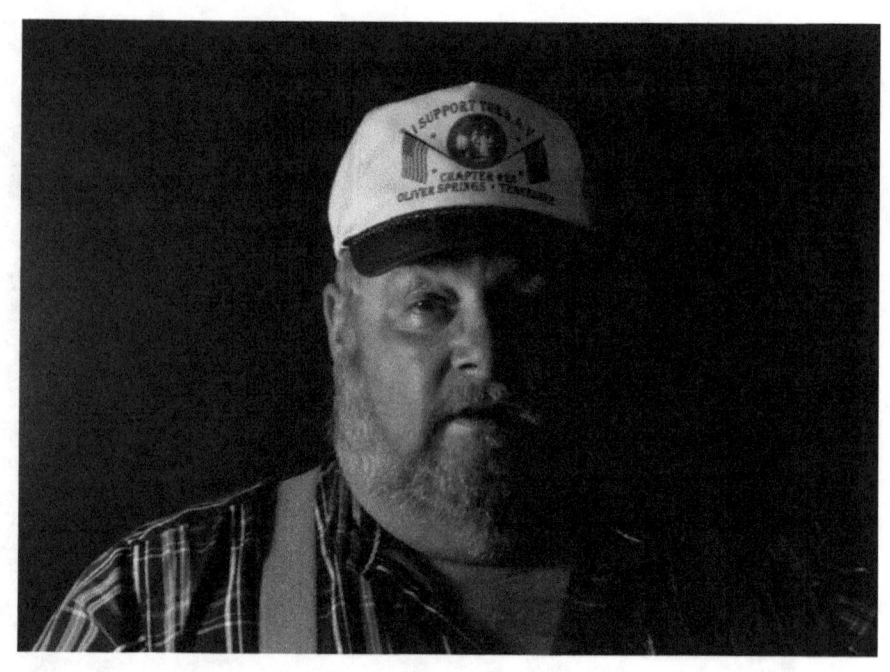

Donald – Army – Mechanic – Vietnam

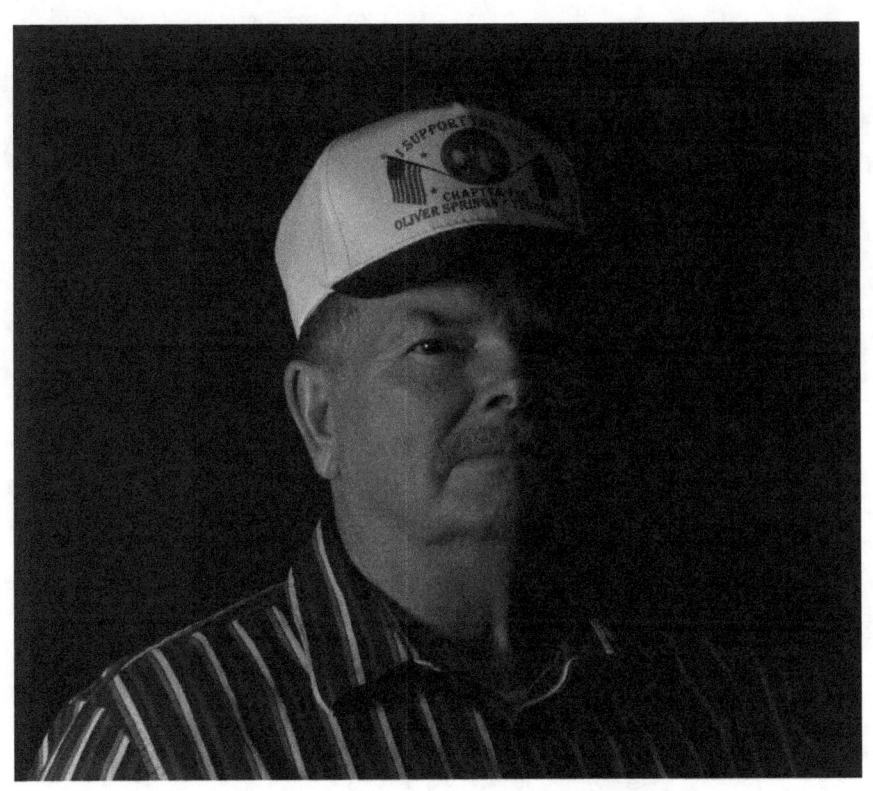

George – Navy – Fleet Support – Vietnam

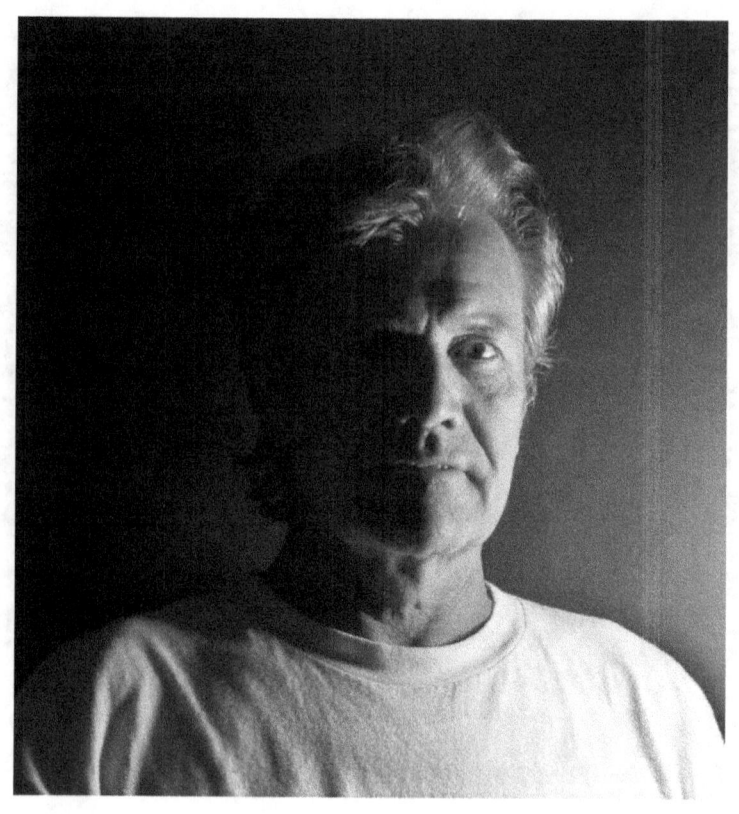

Glen – Air Force – Mechanic/Illustrator – Vietnam

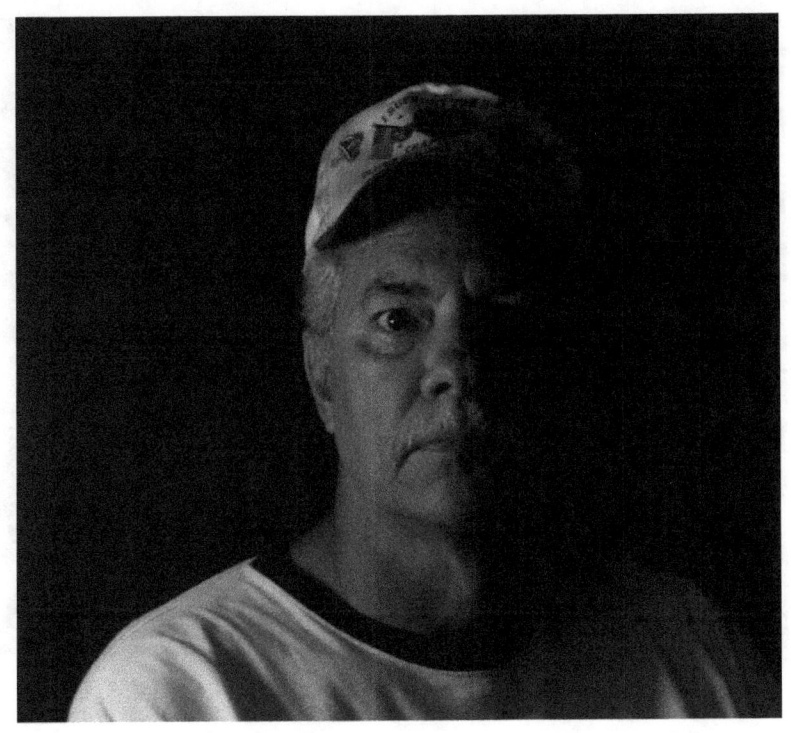

John – Navy – ADJ – Vietnam

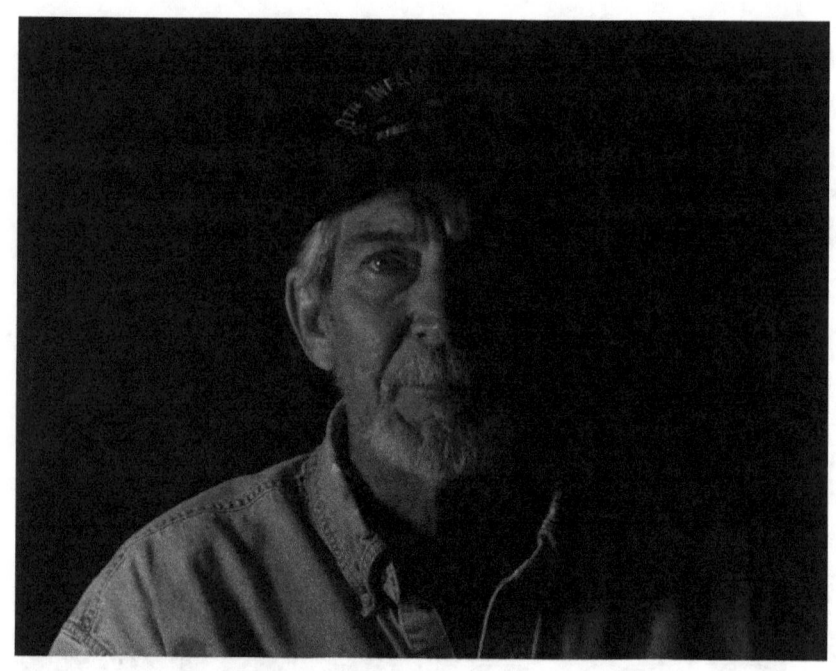

John – Army – Infantry – Vietnam

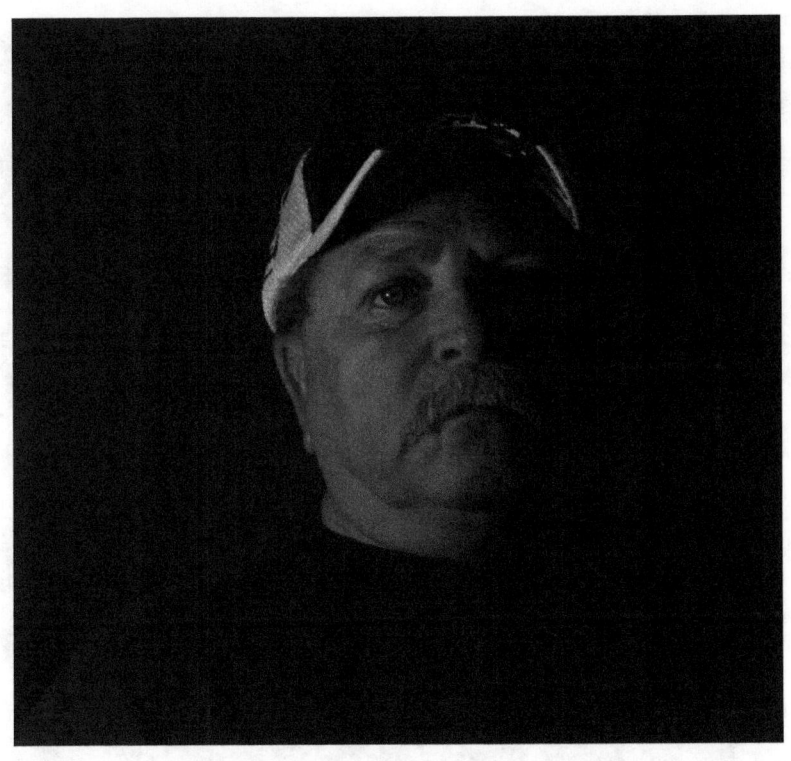

Kenneth – Navy and TN Air National Guard – AMS & ADJ – Vietnam, Desert Storm, Enduring Freedom, Iraqi Freedom

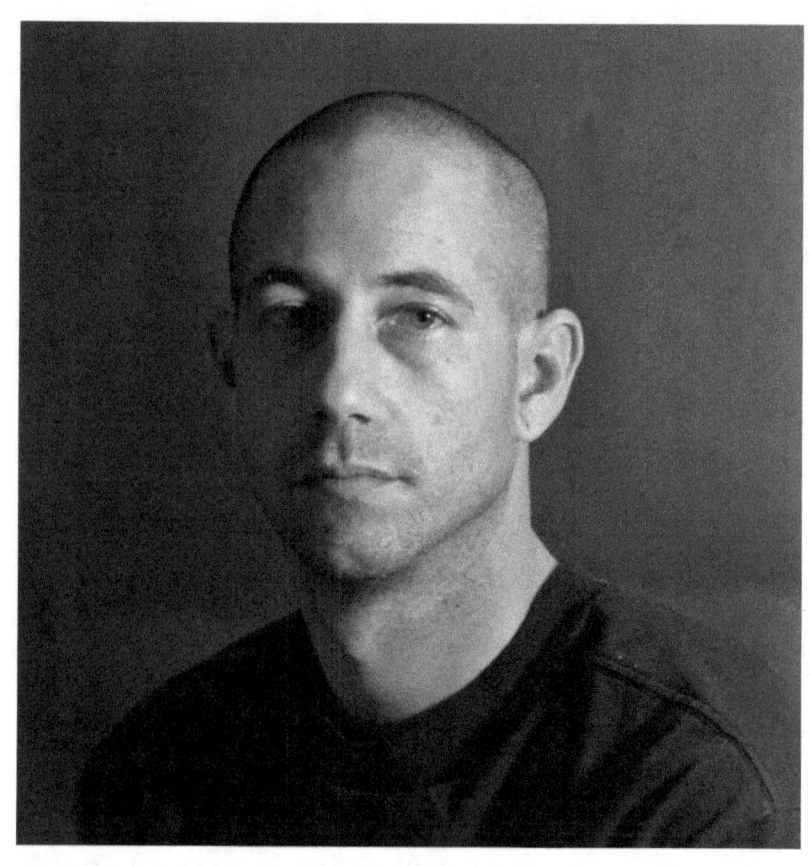

Carl – Air Force – Security Forces – Enduring Freedom and Iraqi Freedom

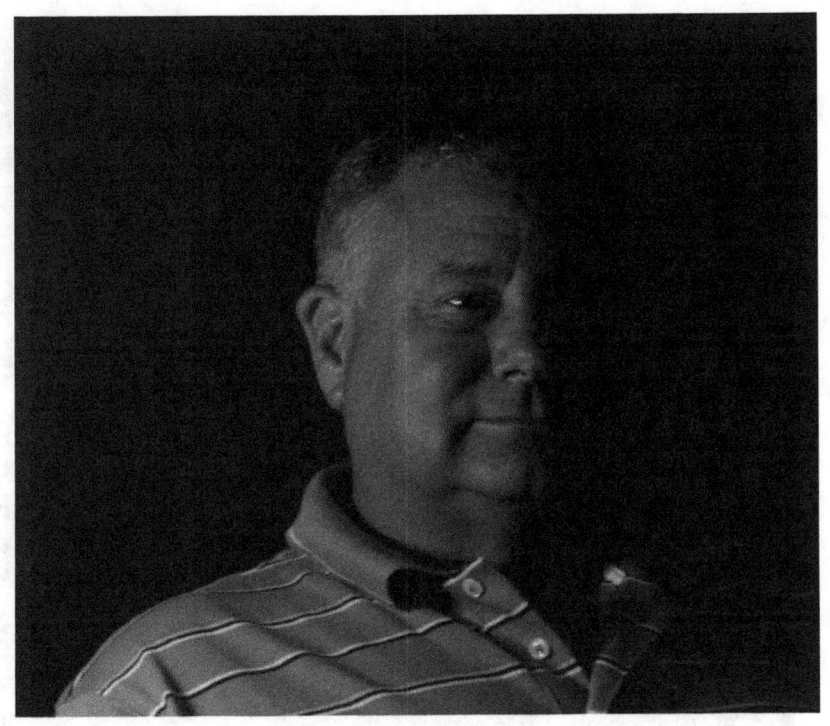

Daniel – Army – Special Forces – Cold War

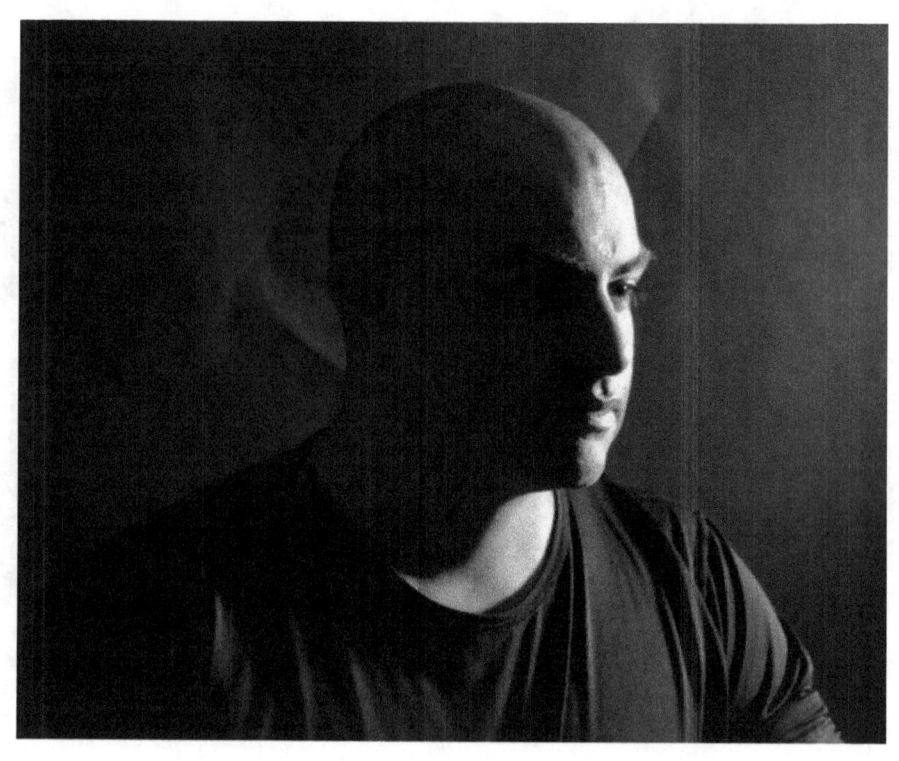

David – Army – Infantry Mortarman – Iraqi Freedom

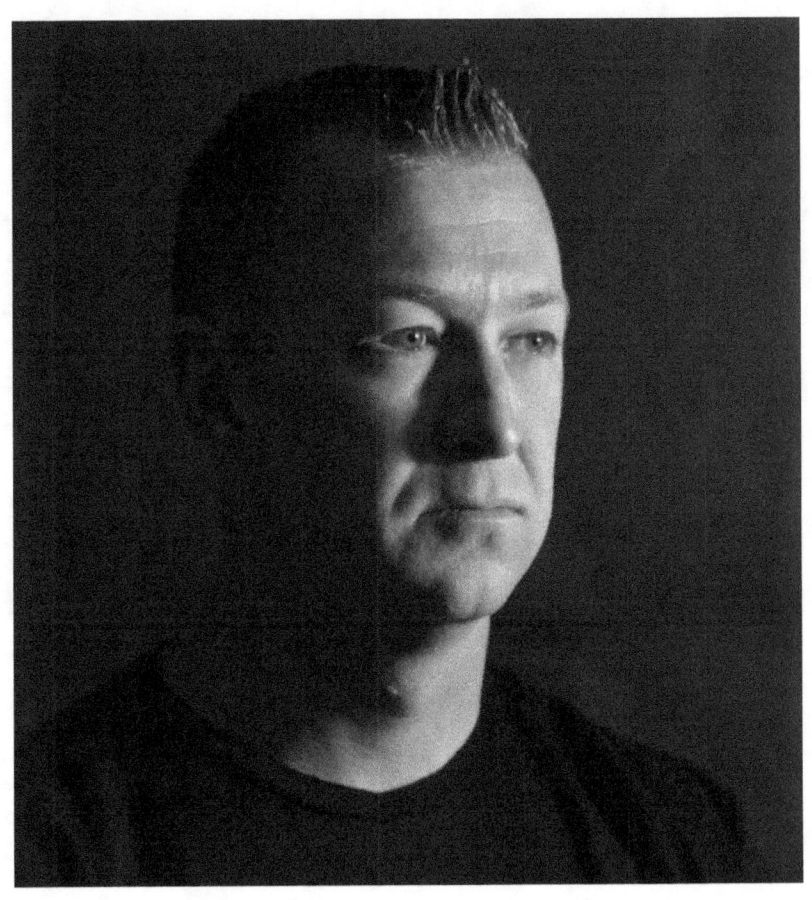

Erik – Air Force – Security Forces – Enduring Freedom

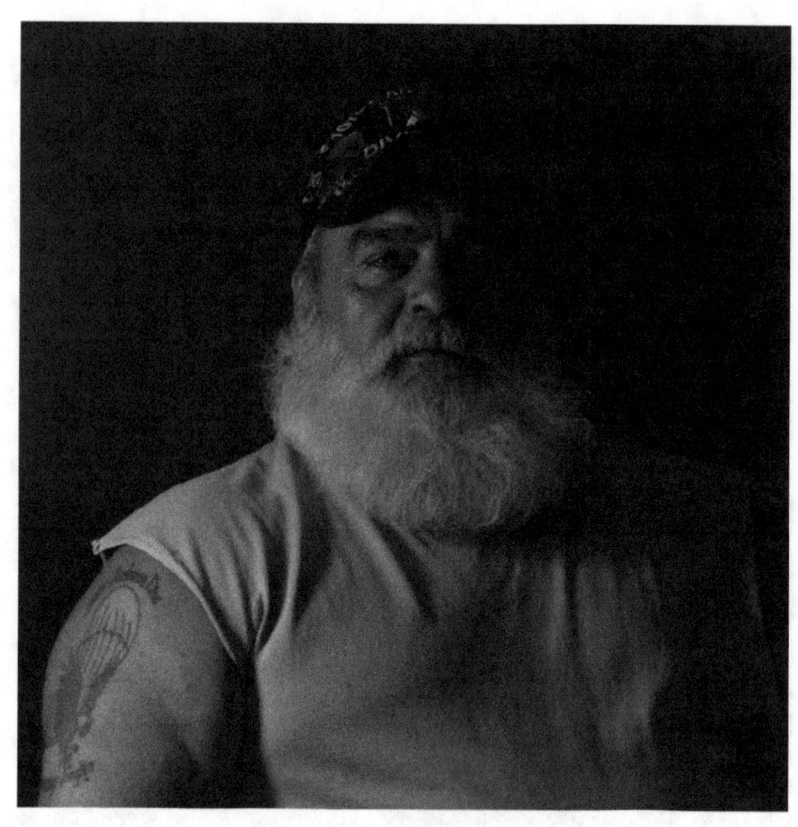

Frank – Army – Airborne – Cold War

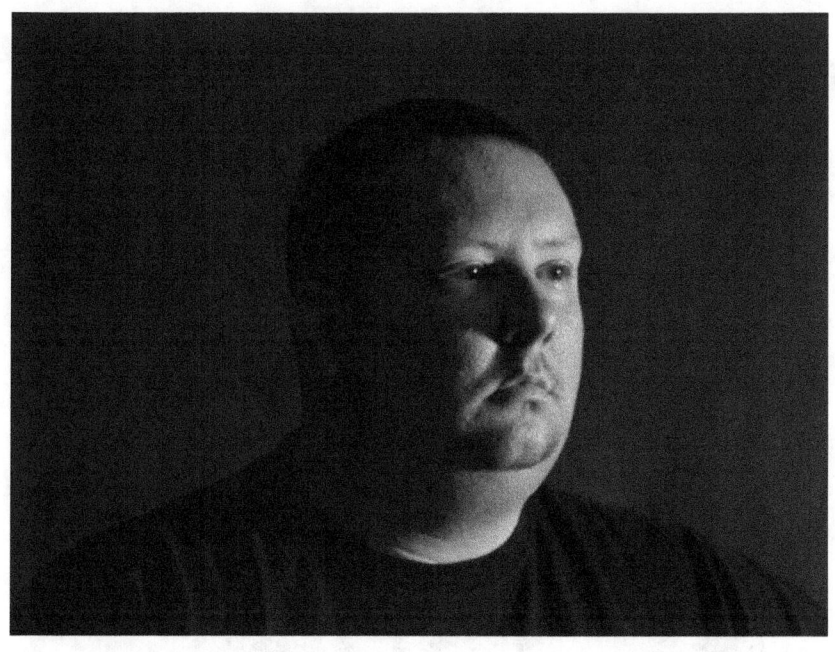

Greg – Army and Air Force – Military Police and Combat Arms – Enduring Freedom and Iraqi Freedom

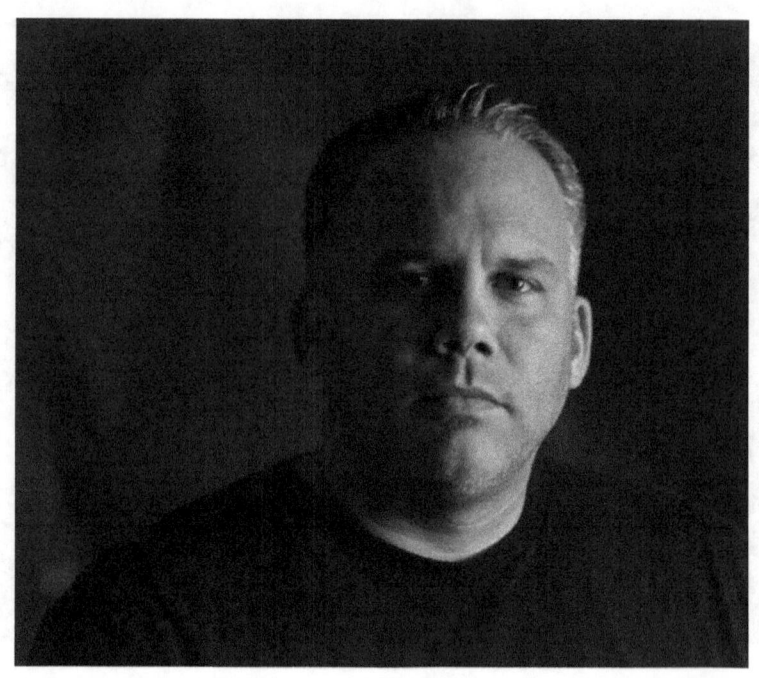

Chris – Air Force – Security Forces – Enduring Freedom and Iraqi Freedom

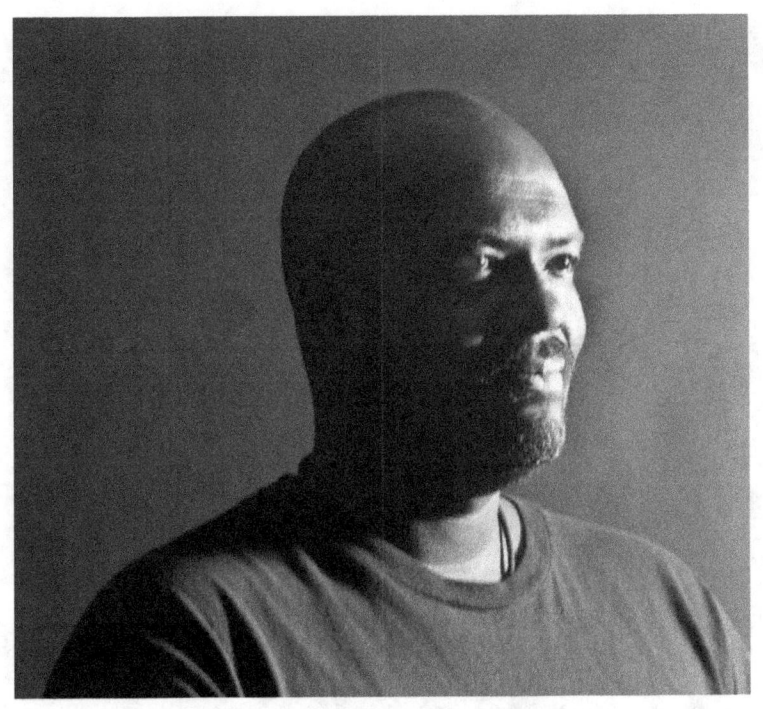

Herb – Air Force – Security Forces – Cold War, Desert Storm, Enduring Freedom, Iraqi Freedom

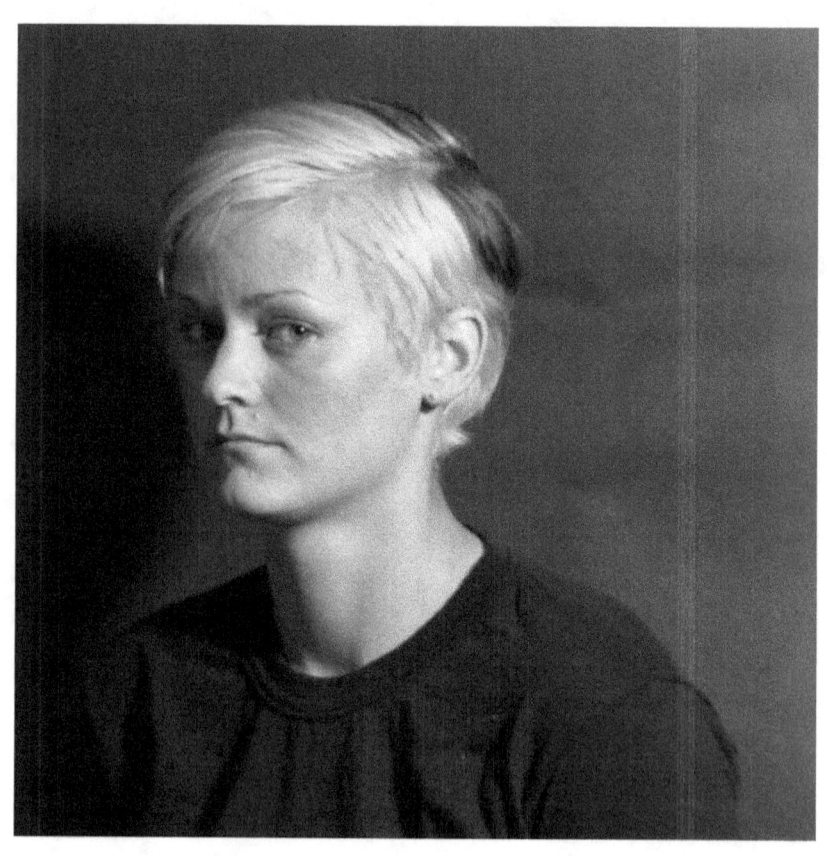

Jessica – Air Force – Combat Arms & Security Forces

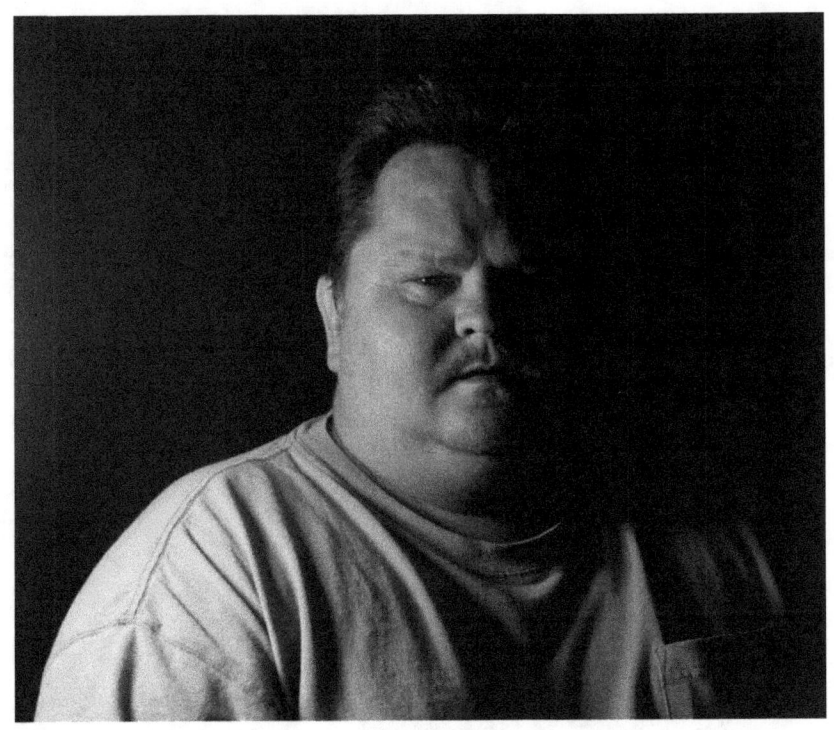

Joel – Army – Airborne – Germany

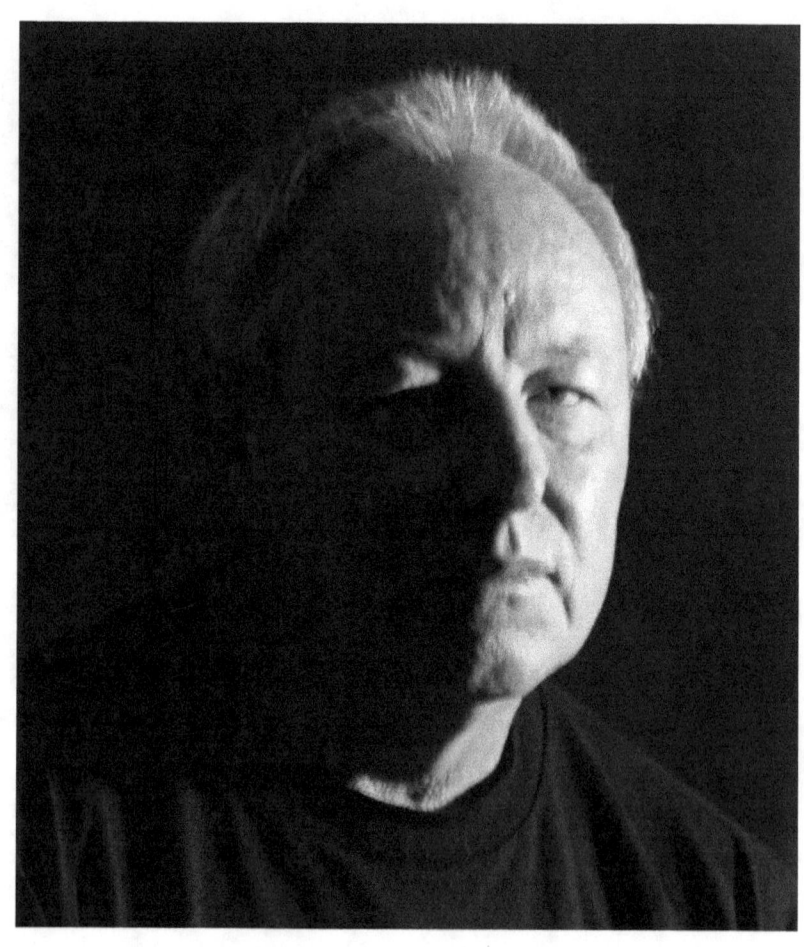

Johnie – Navy – Radioman – Cold War

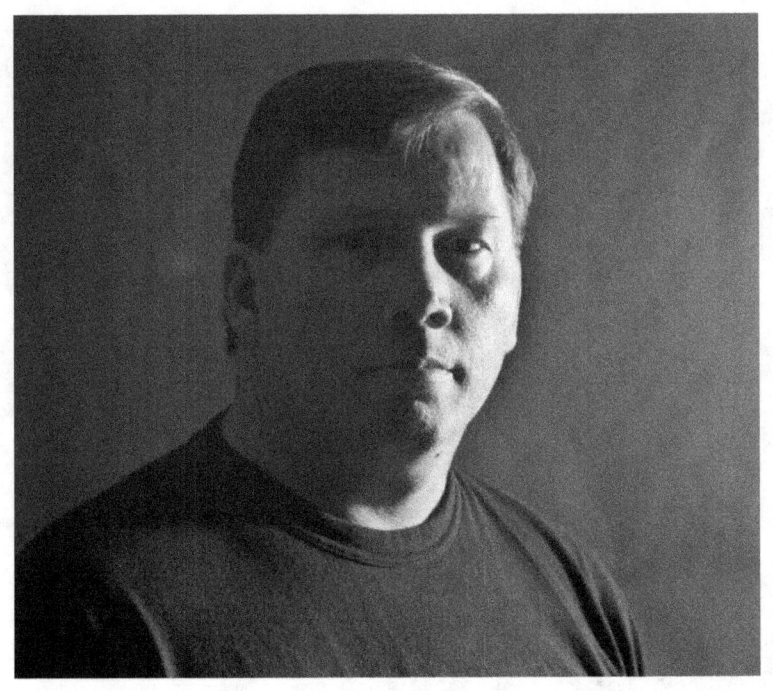

Kevyn – Army/Air Force – Security Forces/Combat Arms – Desert Storm

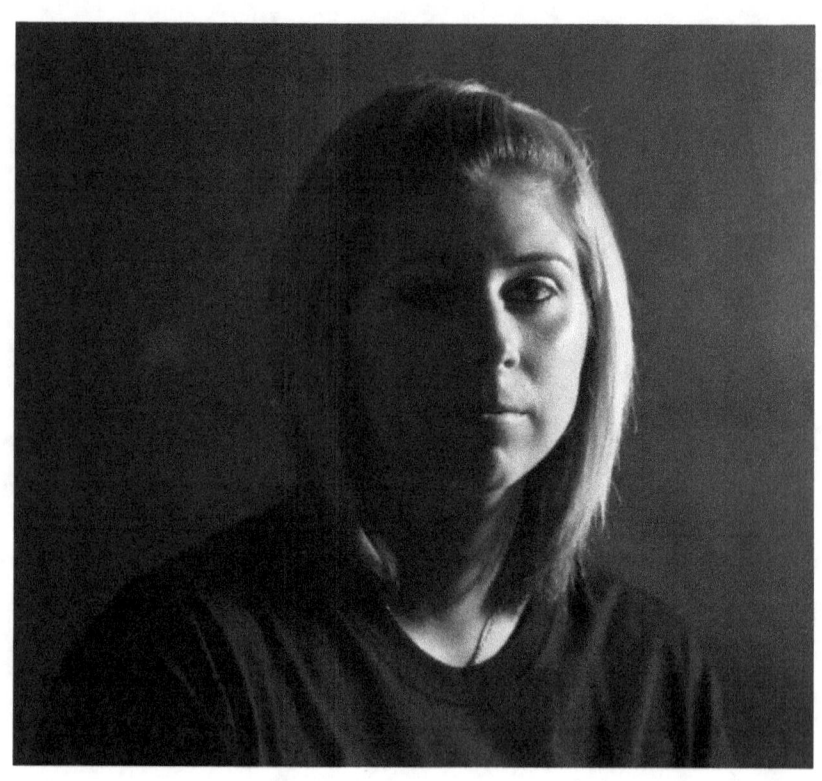

Kim – Air Force – Security Forces – Iraqi Freedom

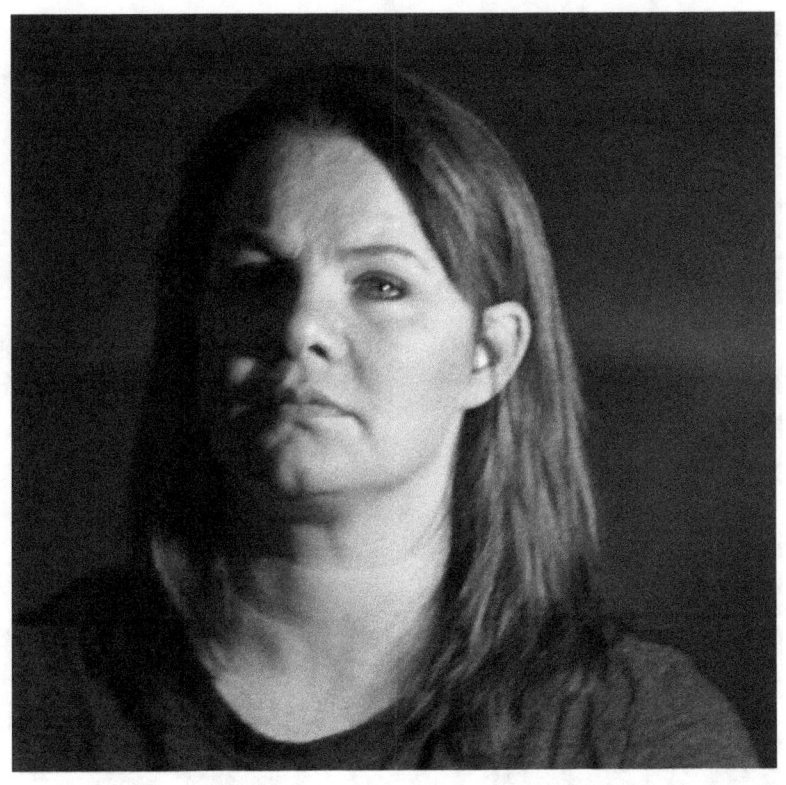

Krystal – Air Force – Security Forces – Enduring Freedom

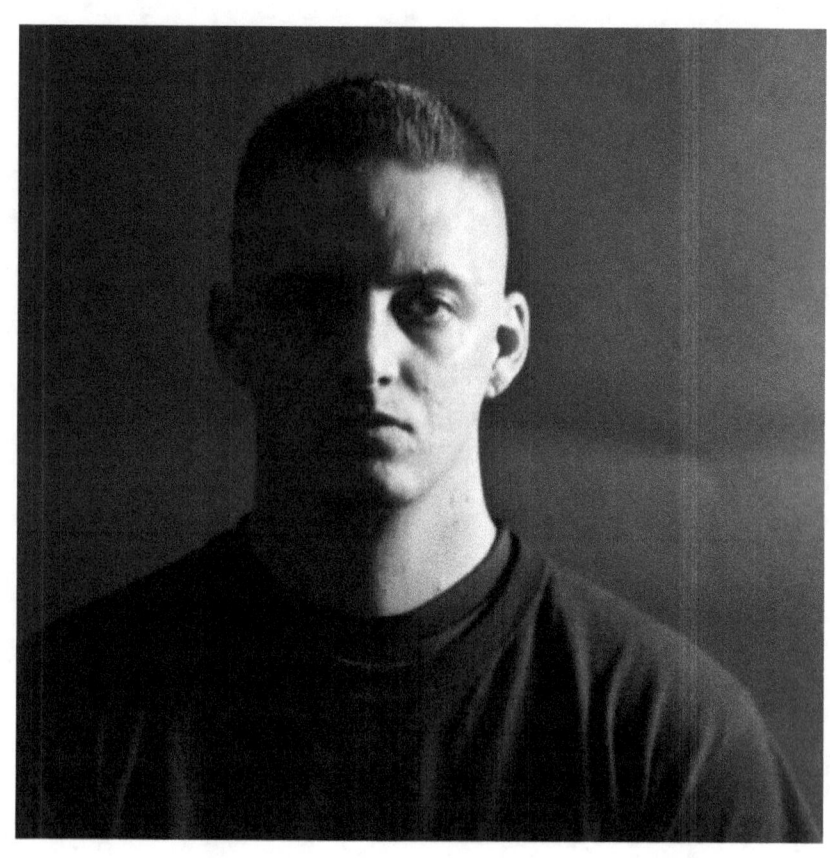

Kyle – Army – Supply Specialist – Iraqi Freedom

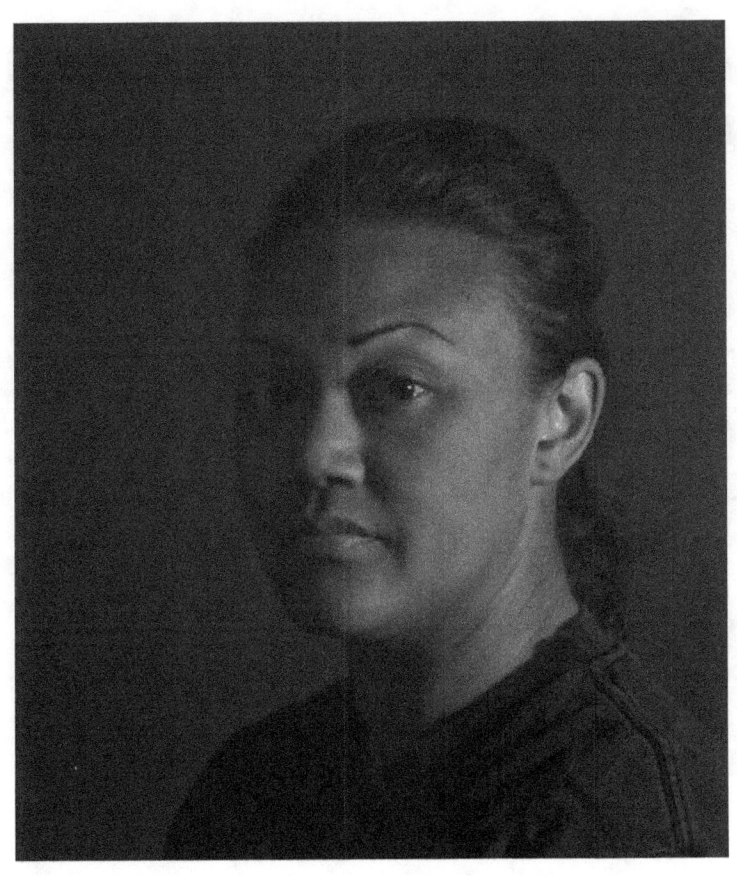

Lan – Air Force – Security Forces – Enduring Freedom

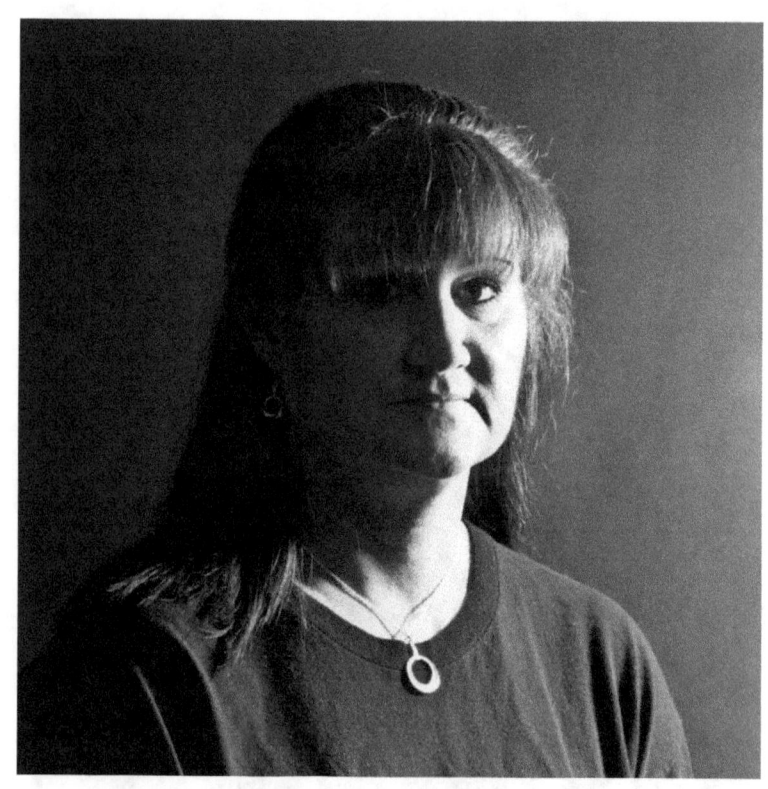

Laura – Air Force – Diet Therapy

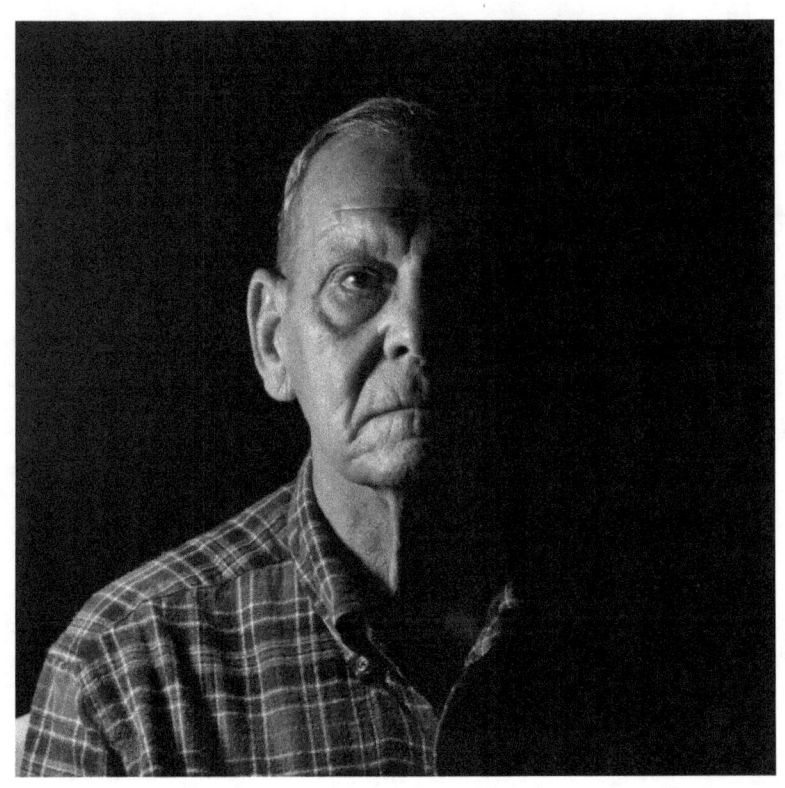

Lee – Navy – Flight Engineer – Vietnam, Bay of Pigs, Suez Canal

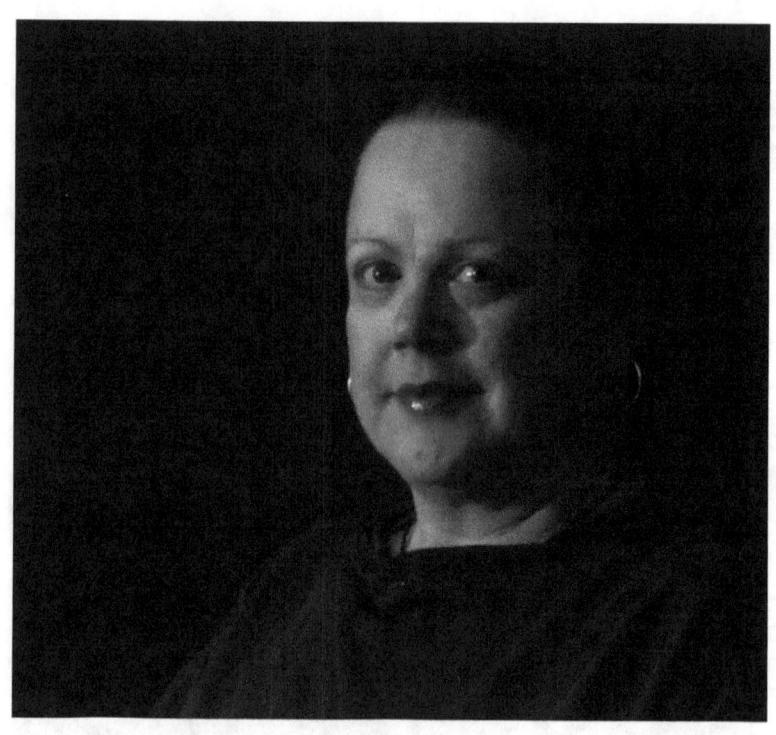

Lise – Air Force – Medic – Cold War, Desert Storm

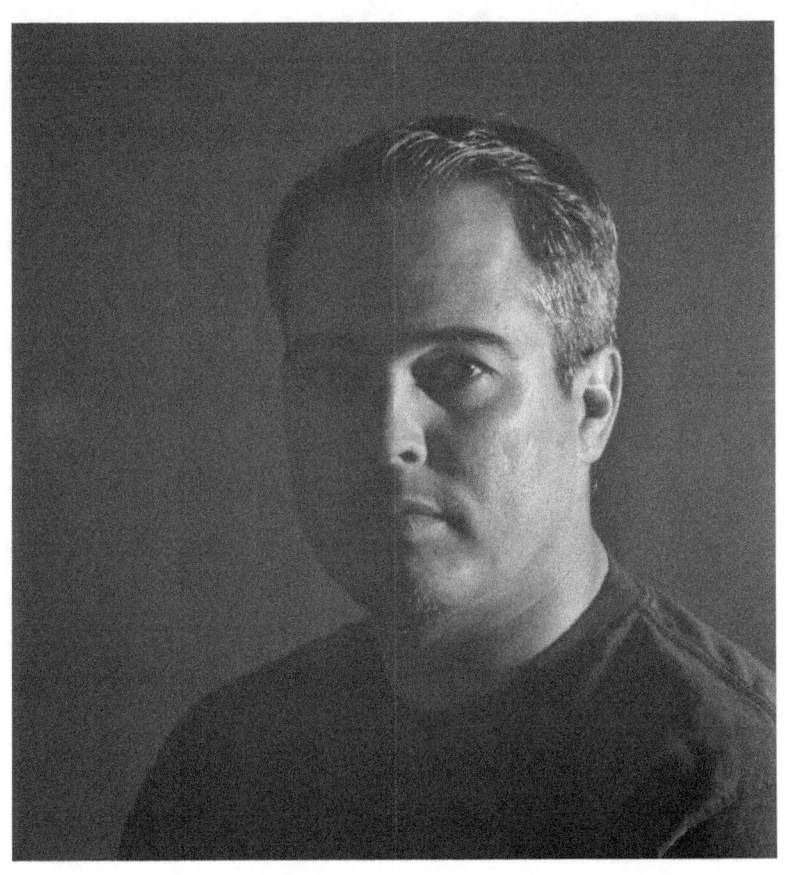

Luis – Air Force – Security Forces – Enduring Freedom, Iraqi Freedom

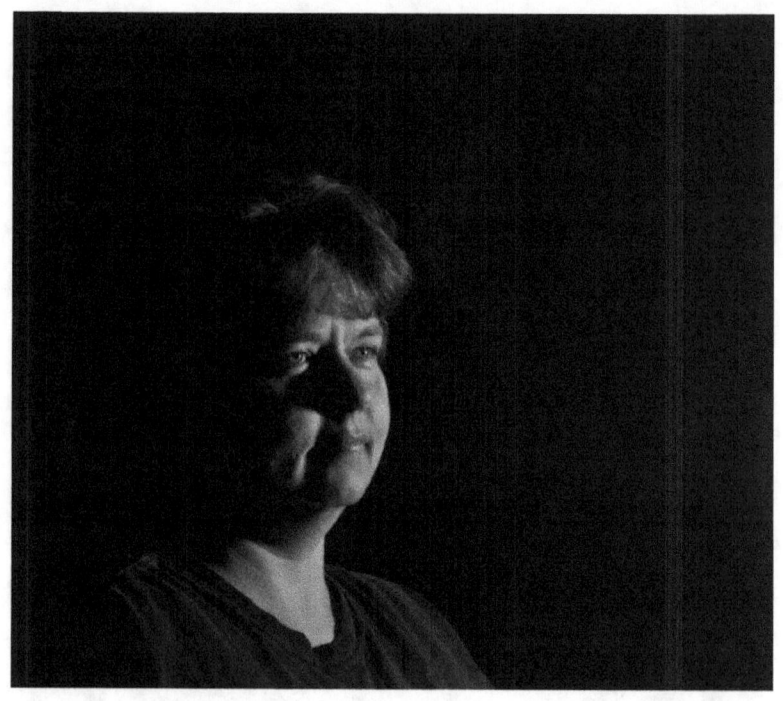

Margaret – Air Force – Passenger and Baggage Clerk – Cold War

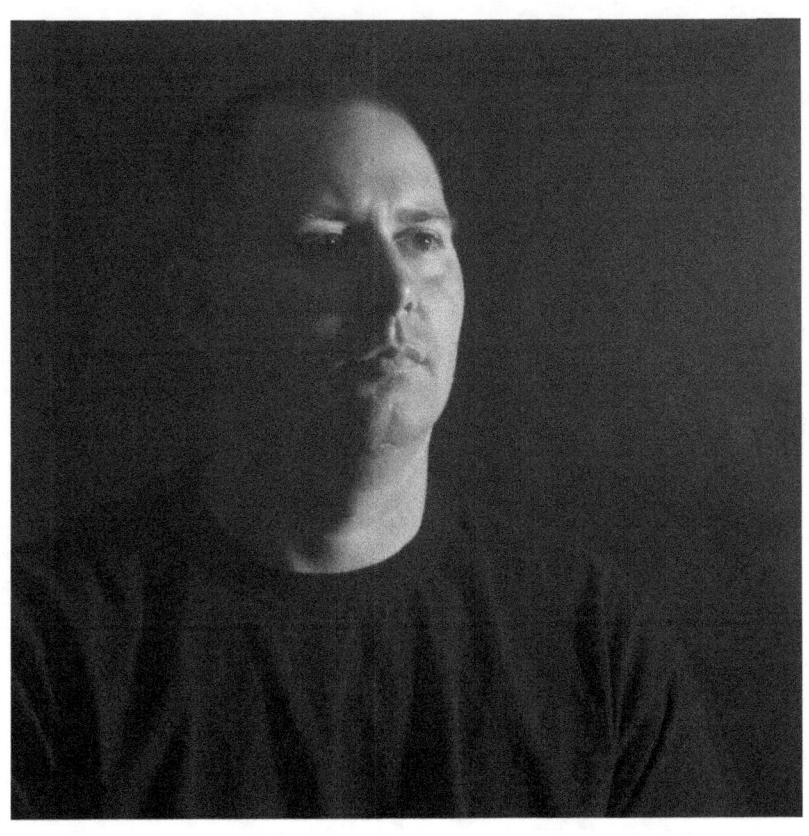

Mark – Air Force – Security Forces – Enduring Freedom and Iraqi Freedom

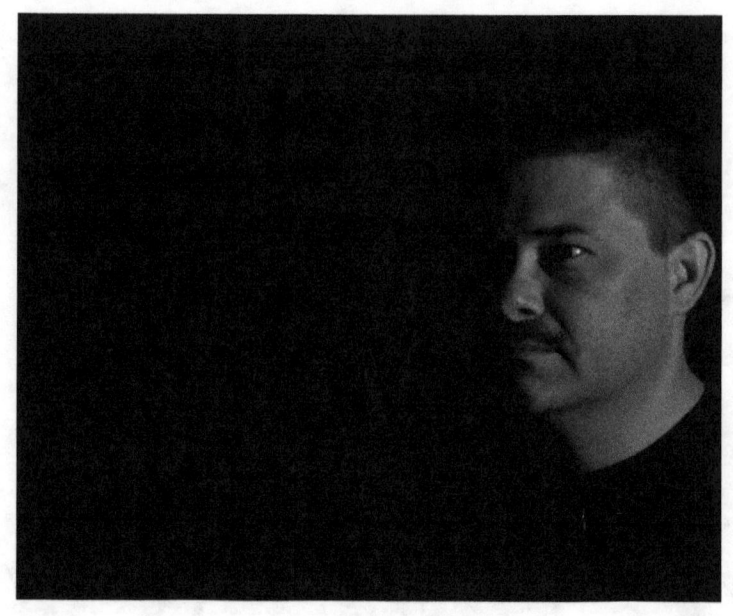

Mark – Air Force – Security Forces – Cold War and Desert Storm

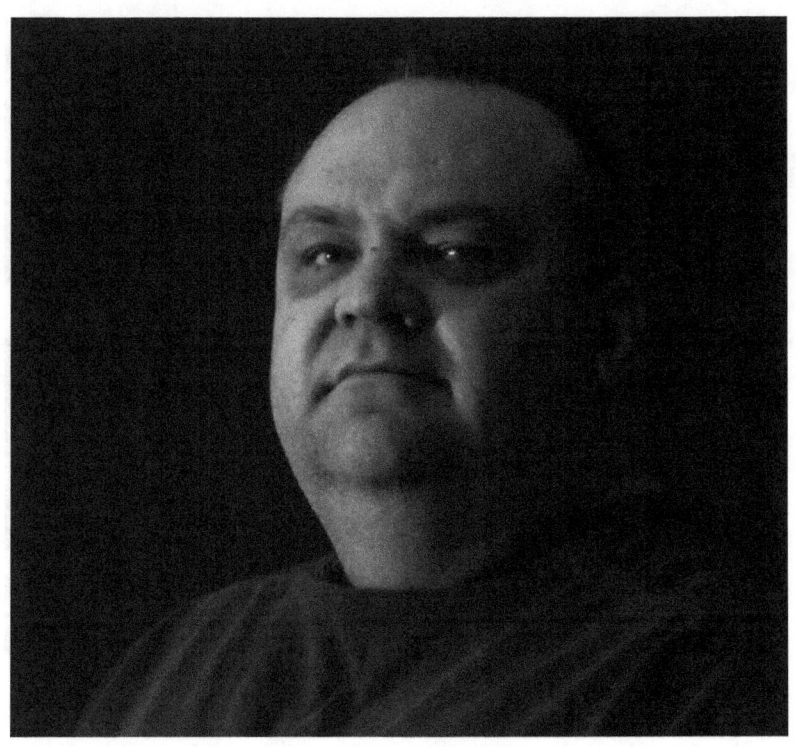

Russel – Air Force – Security Forces/Combat Arms – Cold War, Desert Storm, Enduring Freedom, and Iraqi Freedom

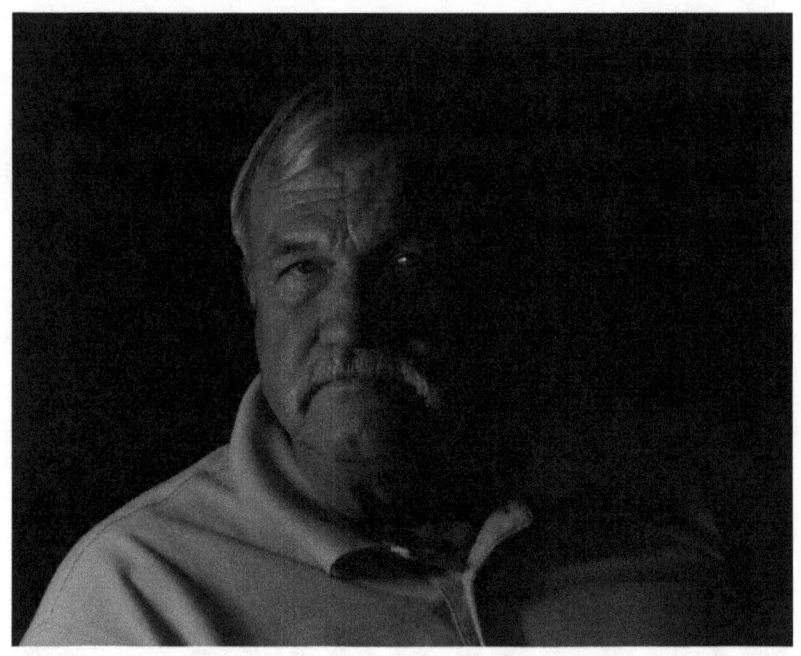

Michael – Air Force – Mechanic – Vietnam

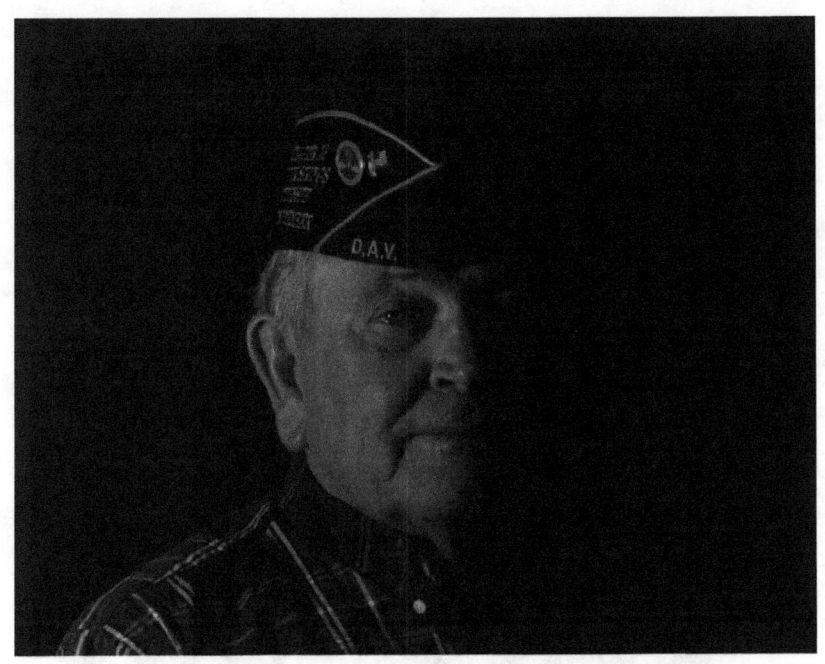

Omer – Air Force – Flight Engineer – Vietnam

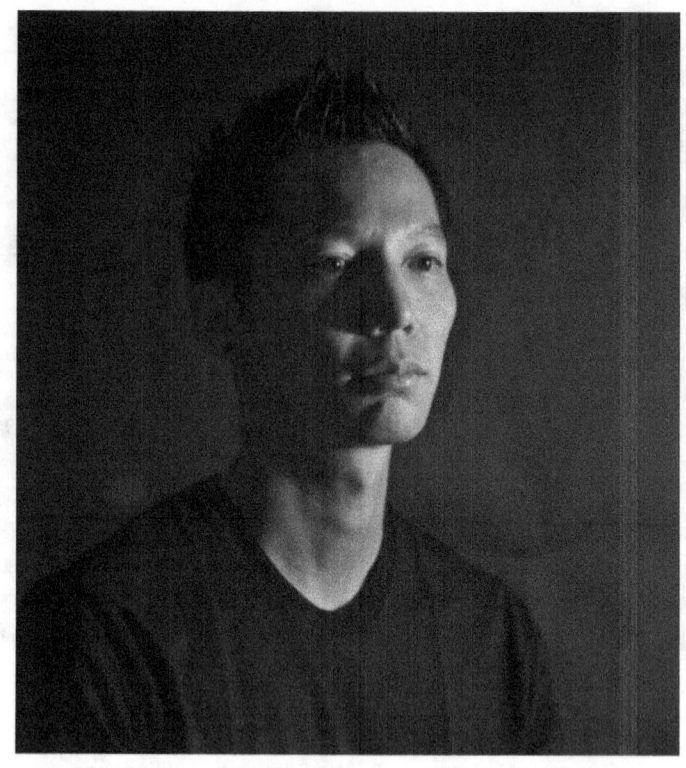

Phil – Air Force – Security Forces – Enduring Freedom, Iraqi Freedom

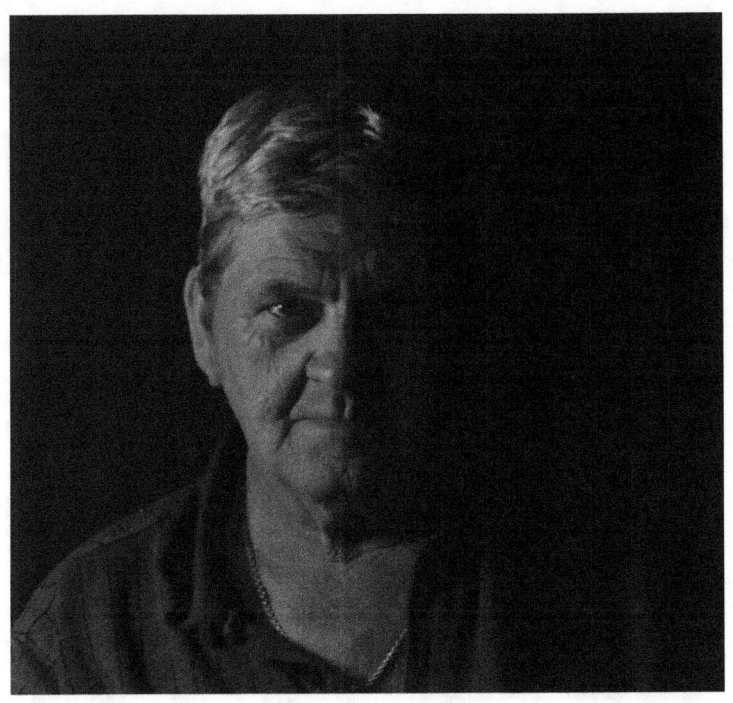

Ralph – Army – Transportation – Vietnam

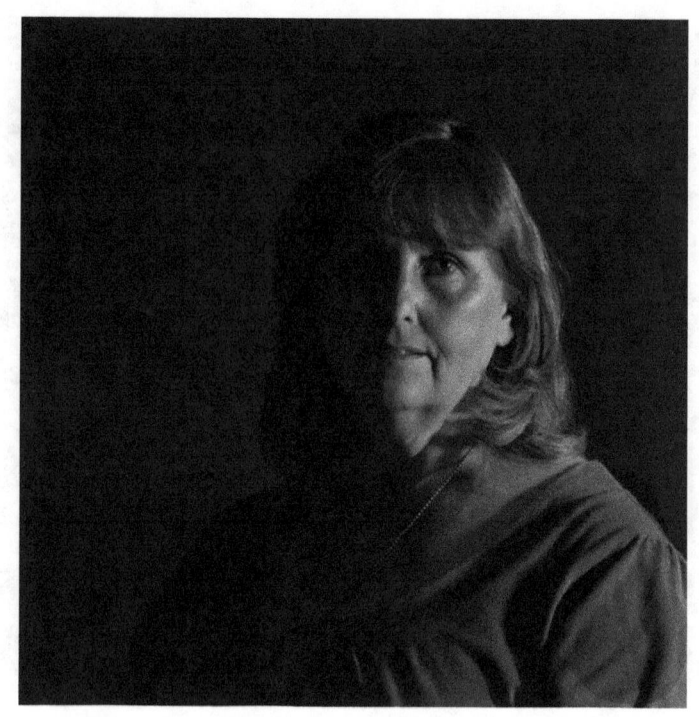

Susan – Army – Truck Driver – Cold War

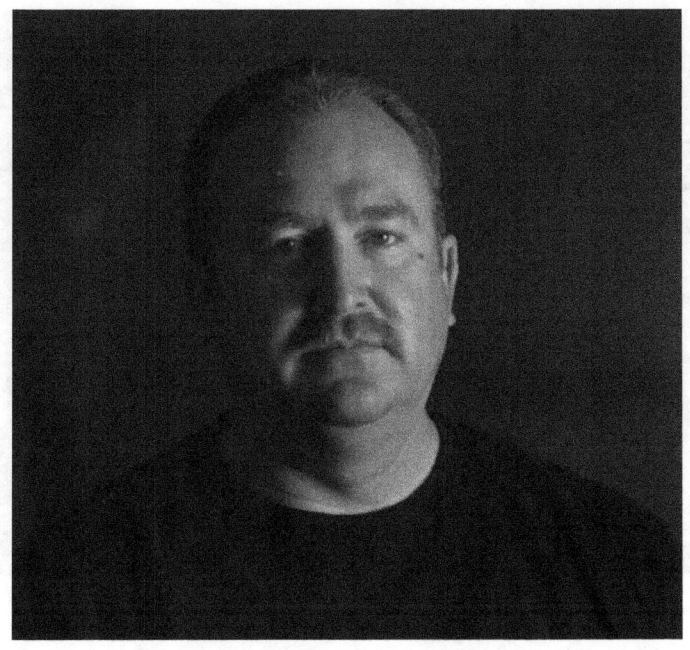

Chuck – Air Force – Security Forces – Cold War, Desert Storm

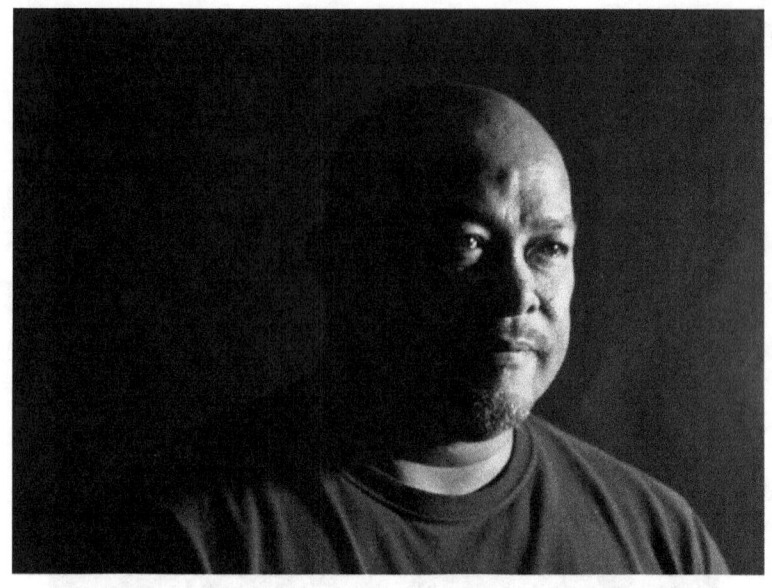

Wayne – Navy – Legal Man – Desert Storm, Enduring Freedom, Iraqi Freedom

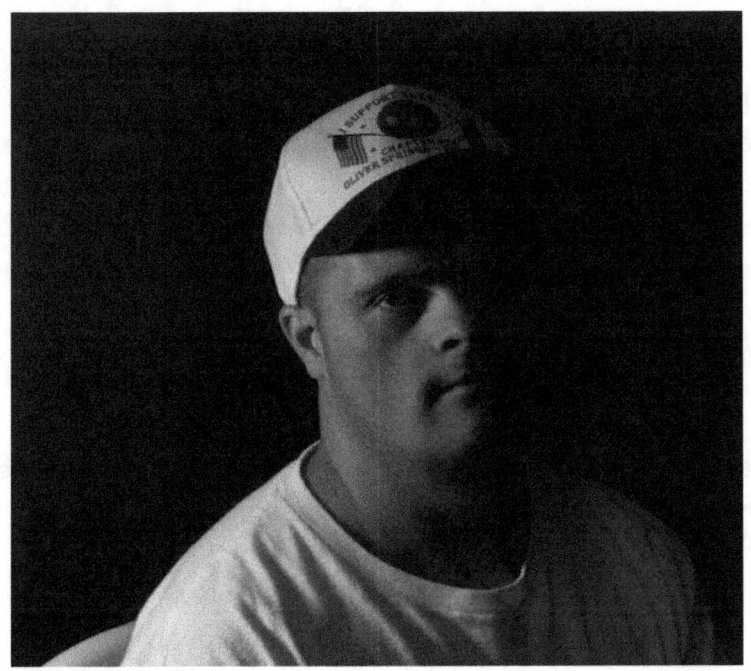

Andy – Warrior at Heart – Not all warriors are veterans. There are those who serve behind the lines and on the home front. Andy stands to represent all those who support our warriors. He has faithfully served the Oliver Springs, TN chapter of the Disabled American Veterans for nine years and counting. Thank you to Andy and to all those he represents.

Introduction

Just what is a veteran? Someone once said that a veteran is "A person who wrote a blank check to the government for a value up to and including his life." That is a fairly accurate statement; however, I feel that the check I wrote was to the American people and not necessarily to the government. I say that because I never did wholly agree with all of the policies of my leaders. Like a good soldier though I followed the lawful orders of those appointed over me for 21 years.

Veterans, be they male or female, are a special breed of people. They joined an organization much bigger than they were and that organization demanded every ounce of them no matter what from day one. From the inception of this country we have called on those willing to serve first to create our nation and later to preserve it and its values. Those willing to don the uniform and do so honorably are truly heroes, whether they served in combat or not. They were all willing to make the ultimate sacrifice for freedom.

The face of the United States veteran has changed over the years. In some eras those faces were covered with facial hair while serving and more recently not. In many cases those faces have always been male and most recently we have begun to see females. The one thing that has not changed in the United States service member is a willingness to get the job done no

matter the cost. Service members swear an oath and live by a code. They possess qualities like courage and honor hidden deep within their souls that can never truly be understood by those who have never served.

This project was born to honor those who served and continue to serve. It was born of a desire to give back to those who have given so much and to call attention to the face next to you in the mall. As you can see from the variety of faces on these pages, the small woman standing next to you may have, at one time, put her life on the line so you can enjoy your day of shopping. Remember that the next time a stranger needs help. He may not be homeless due to his choices; he may be homeless due to his sacrifices.

If you have never had the privilege and honor to wear the uniform, remember these words and the courage it takes to utter them as you flip through these pages:

The Commissioning Oath

"I, _____ , having been appointed an officer in the (Service) of the United States, as indicated above in the grade of _____ do solemnly swear that I will support and defend the Constitution of the United States against all enemies, foreign or domestic, that I will bear true faith and allegiance to the same; that I take this obligation freely, without any mental reservations or purpose of evasion; and that I will well and faithfully

discharge the duties of the office upon which I am about to enter; So help me God."

The Enlistment Oath

"I, _____, do solemnly swear that I will support and defend the Constitution of the United States against all enemies, foreign and domestic; that I will bear true faith and allegiance to the same; and that I will obey the orders of the President of the United States and the orders of the officers appointed over me, according to regulations and the Uniform Code of Military Justice. So help me God."

A little about the brotherhood of veterans and service members is appropriate here. First I would like to say that the term brotherhood automatically extends to our female comrades who have worn and do wear the uniform with pride, honor, and dignity. In the world of the veteran there is no male and female, only veterans. Secondly being in the military forms bonds that often span lifetimes. No matter if you were in combat or not, military service has filled you with good memories and often supplied you with good friends. Bonds formed in combat are the strongest bonds. It is impossible to face death with others and not bond with them on the most intimate of levels.

I hope this book accomplishes something that not many have been done in the past. I hope that it draws attention to the

service and sacrifice of those who wear and have worn the nation's uniform. It is also important to note what I mean about serving during a war. If your years of service indicate to me that you were in the military during a war, whether or not you deployed, you served during that war. This book is about the sacrifice of the veteran and includes sacrifices that happened and those who were prepared to sacrifice it all. I have tried hard to exclude no one in this, the first volume of this book.

The Saint Crispin's Day Speech

Henry V

William Shakespeare

"This day is called the Feast of Crispian.
He that outlives this day and comes safe home
Will stand a-tiptoe when this day is named
And rouse him at the name of Crispian.
He that shall see this day and live t' old age
Will yearly on the vigil feast his neighbours
And say, "Tomorrow is Saint Crispian."
Then will he strip his sleeve and show his scars
And say, "These wounds I had on Crispin's day."
Old men forget; yet all shall be forgot,
But he'll remember, with advantages
What feats he did that day. Then shall our names,
Familiar in his mouth as household words —
Harry the King, Bedford and Exeter,
Warwick and Talbot, Salisbury and Gloucester —
Be in their flowing cups freshly remembered.
This story shall the good man teach his son,
And Crispin Crispian shall ne'er go by
From this day to the ending of the world,
But we in it shall be remembered,
We few, we happy few, we band of brothers.
For he today that sheds his blood with me
Shall be my brother; be he ne'er so vile,

This day shall gentle his condition.
And gentlemen in England now abed
Shall think themselves accursed they were not here,
And hold their manhoods cheap whiles any speaks
That fought with us upon Saint Crispian's Day."

"When I go to war I want the whiskey drinkers. You can keep the milk drinkers."

- Stanley A Mozak
Master Sergeant (Retired), Unite States Air Force

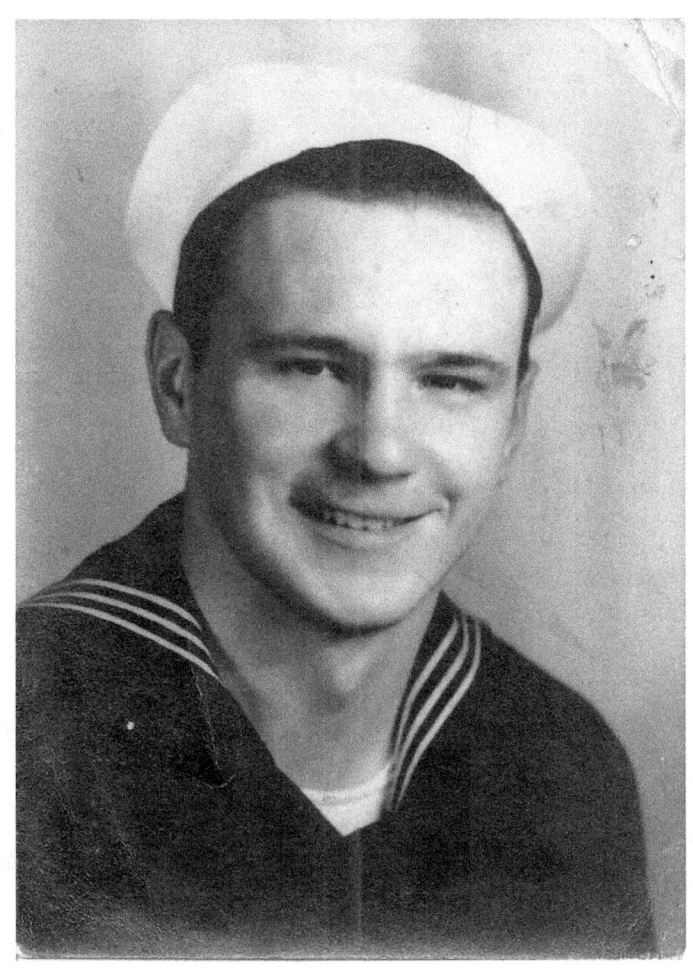

Walter – Navy – Torpedoman – WWII – My Dad, My Hero

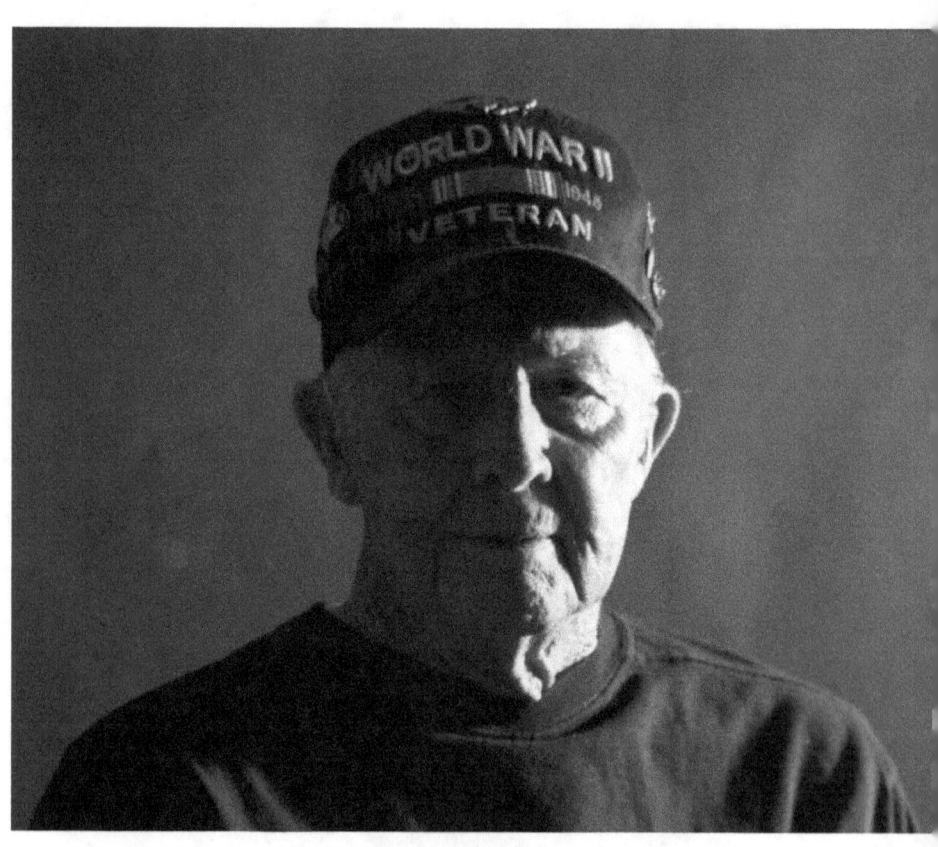

Earl – Army Air Corps and Air Force – WWII, Berlin Airlift, Korea, Vietnam

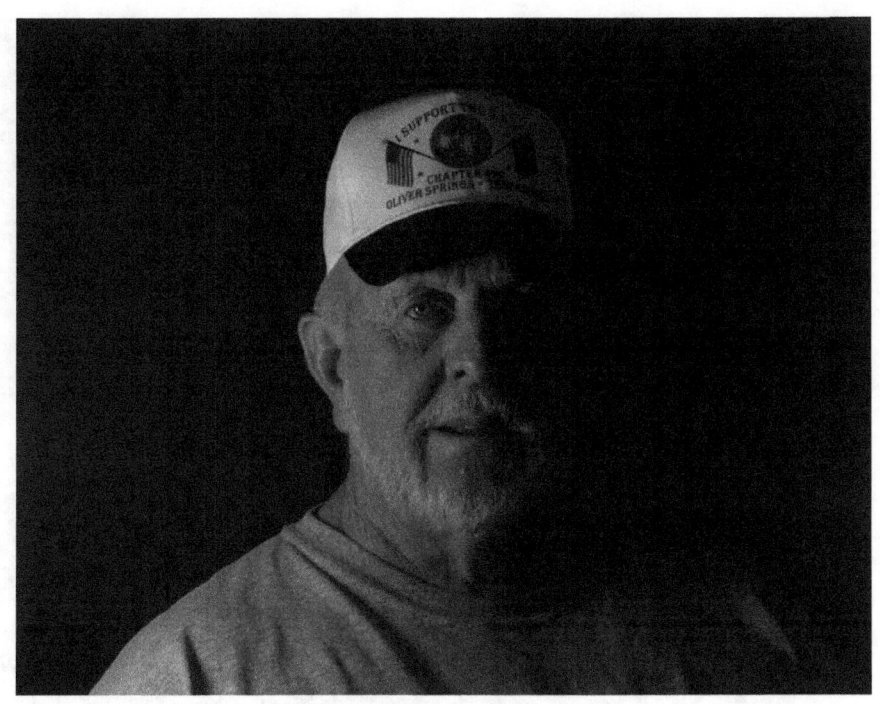

Charlie – Army – Supply Specialist – Vietnam

Dennis – Army – Combat Engineer – Vietnam

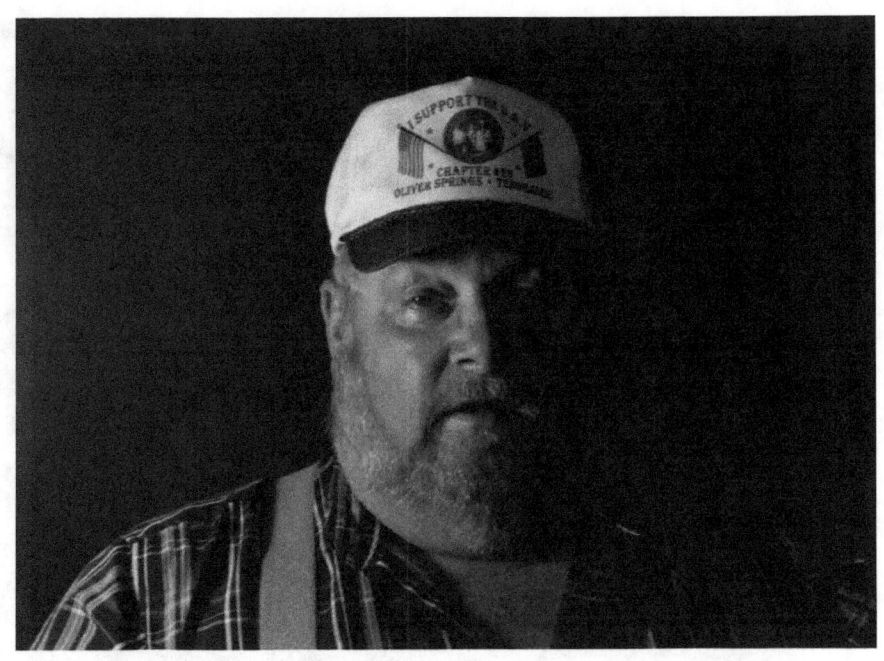

Donald – Army – Mechanic – Vietnam

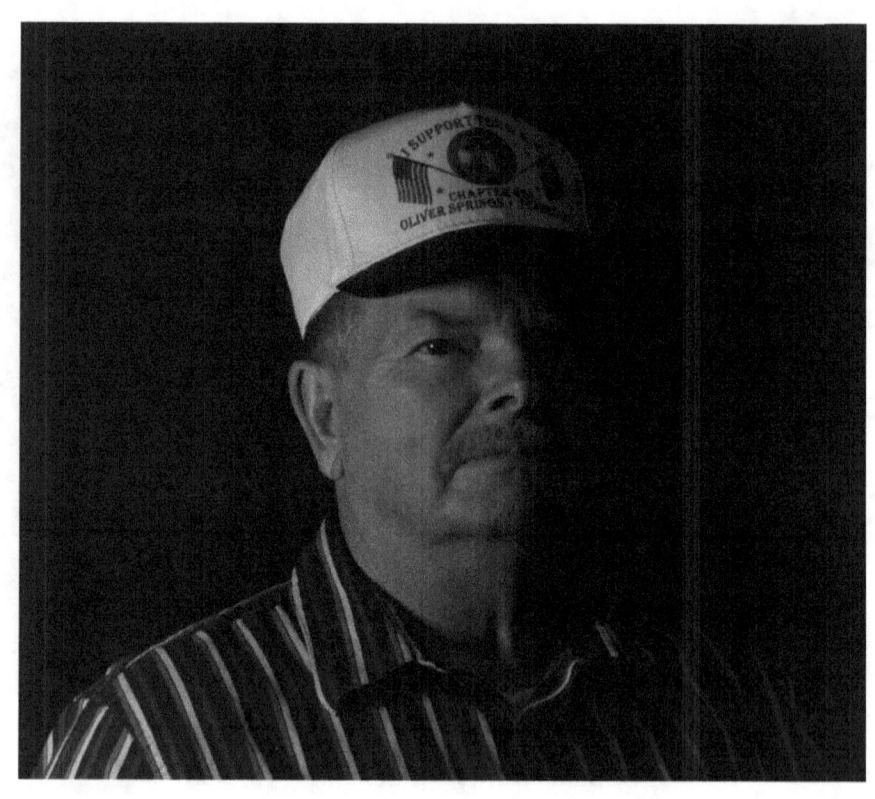

George – Navy – Fleet Support – Vietnam

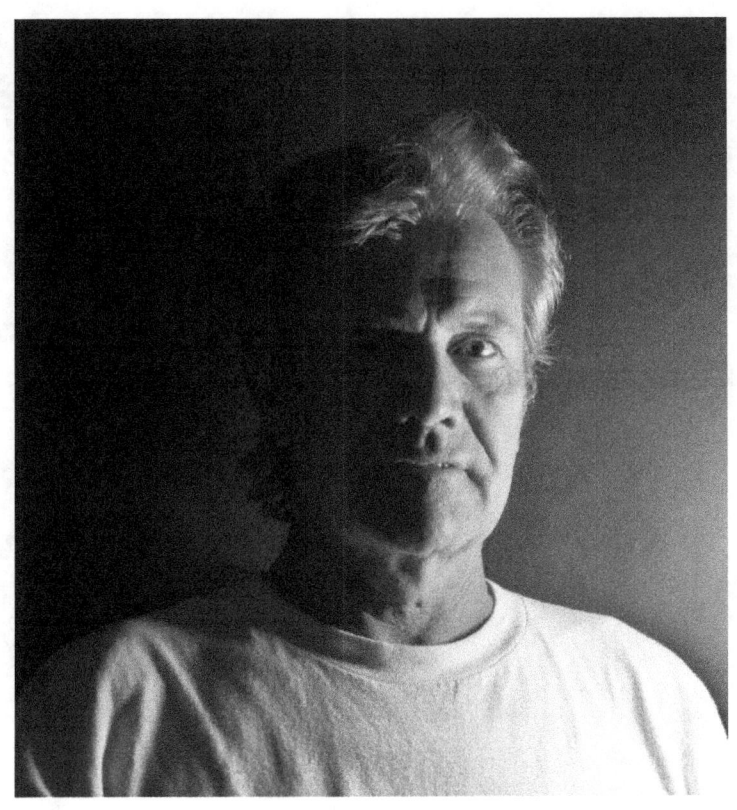

Glen – Air Force – Mechanic/Illustrator – Vietnam

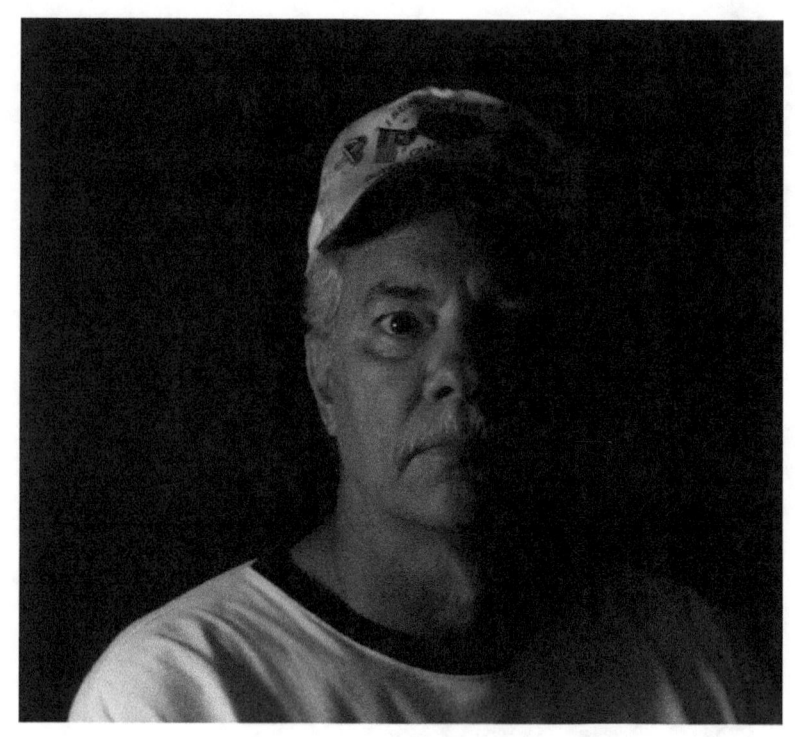

John – Navy – ADJ – Vietnam

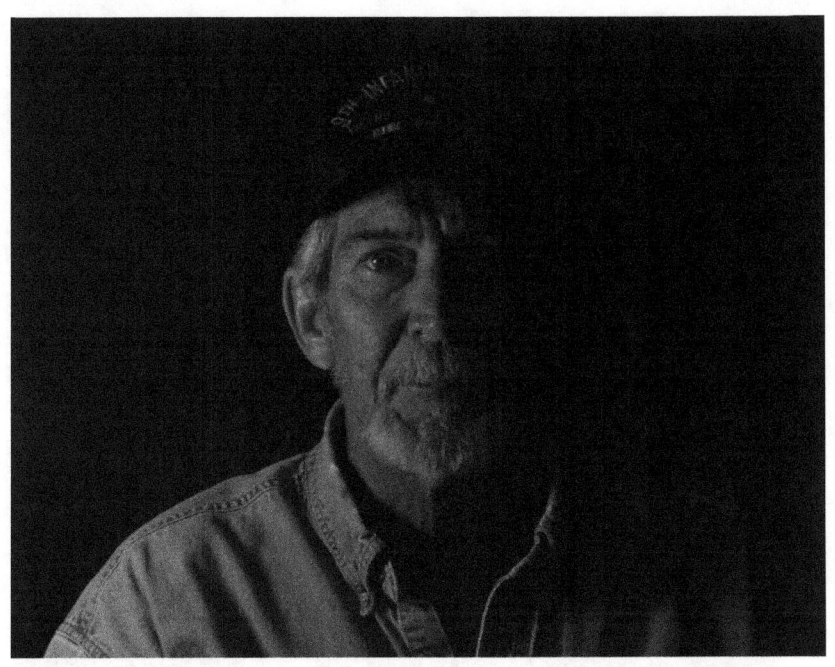

John – Army – Infantry – Vietnam

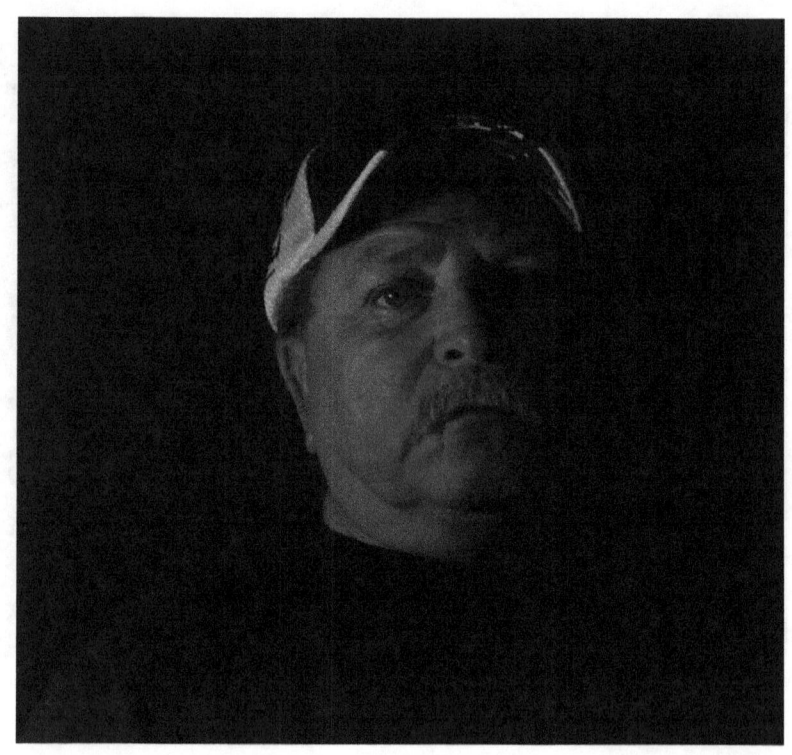

Kenneth – Navy and TN Air National Guard – AMS & ADJ – Vietnam, Desert Storm, Enduring Freedom, Iraqi Freedom

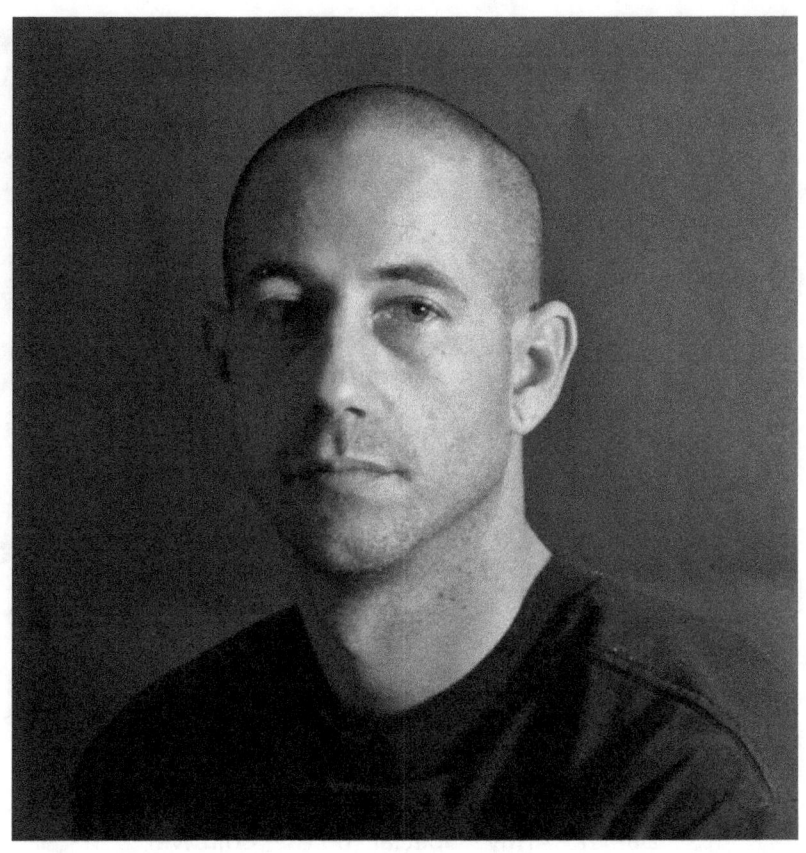

Carl – Air Force – Security Forces – Enduring Freedom and Iraqi Freedom

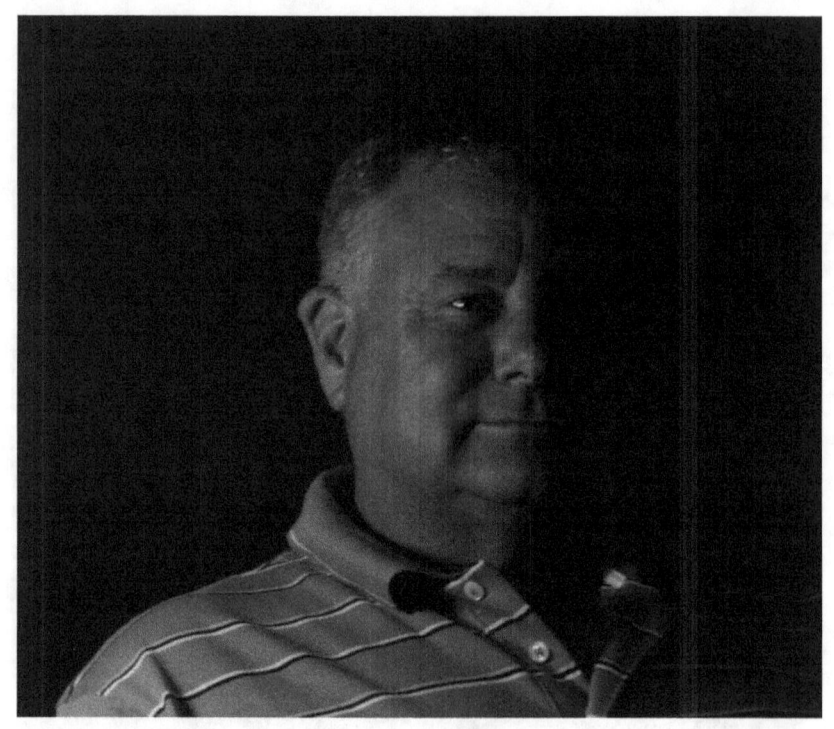

Daniel – Army – Special Forces – Cold War

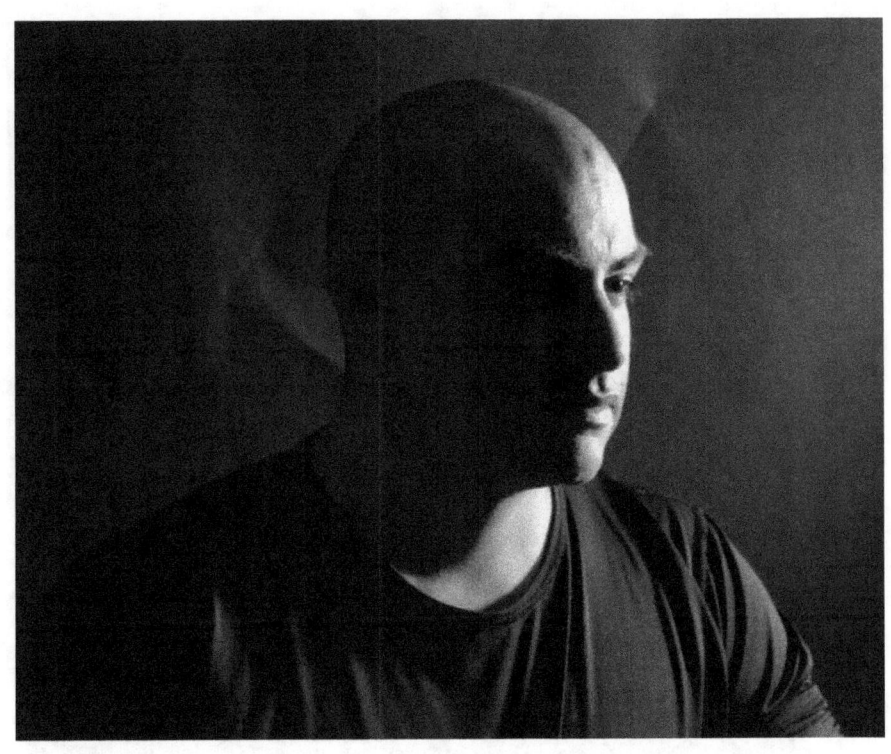

David – Army – Infantry Mortarman – Iraqi Freedom

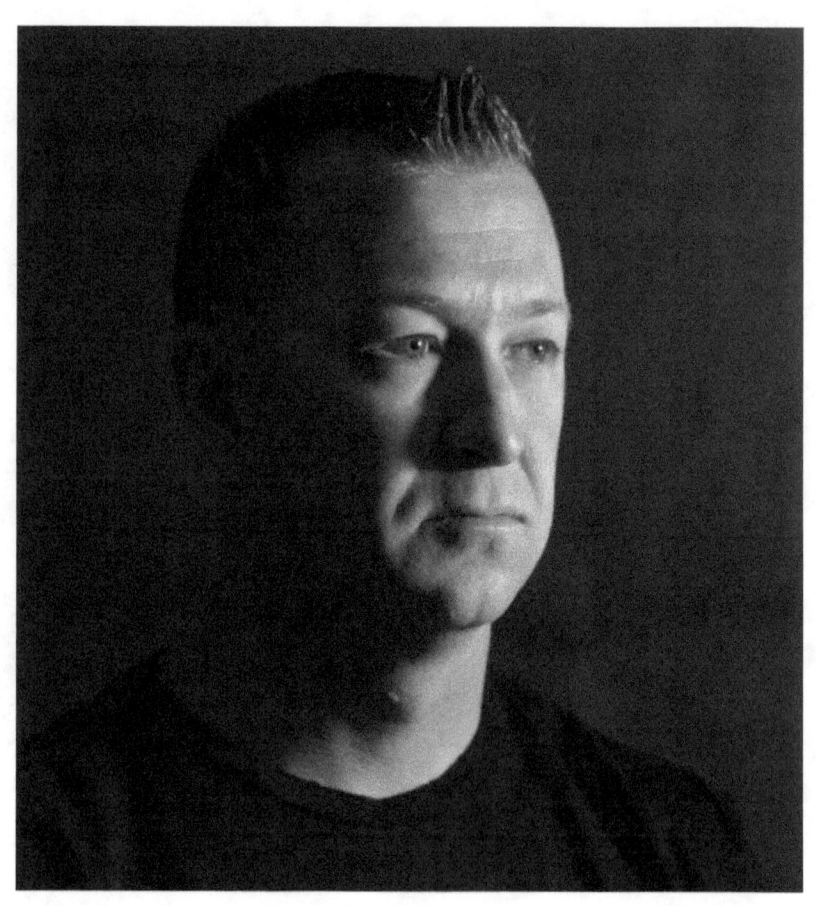

Erik – Air Force – Security Forces – Enduring Freedom

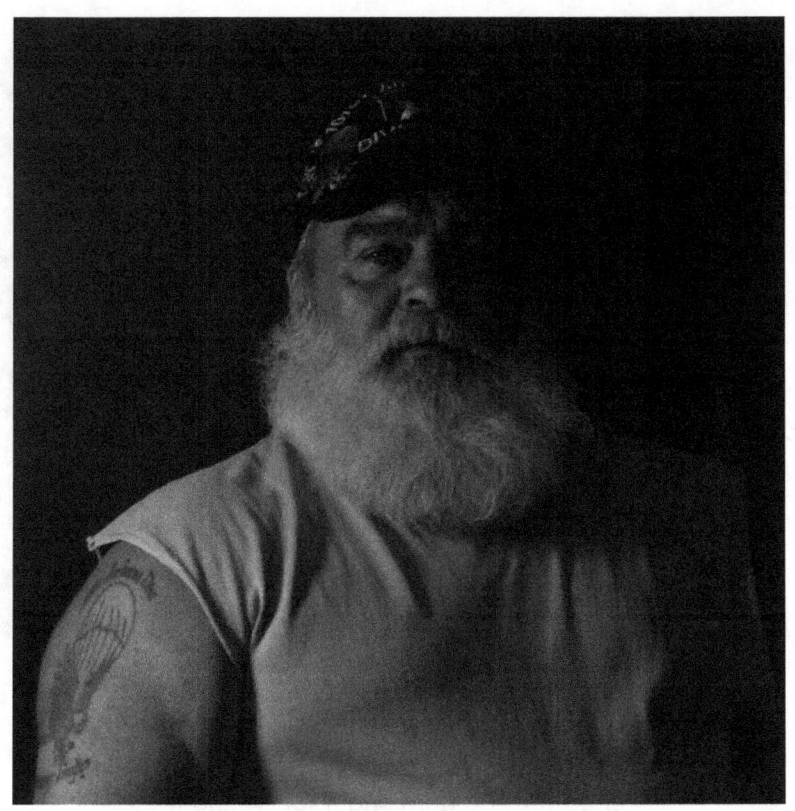

Frank – Army – Airborne – Cold War

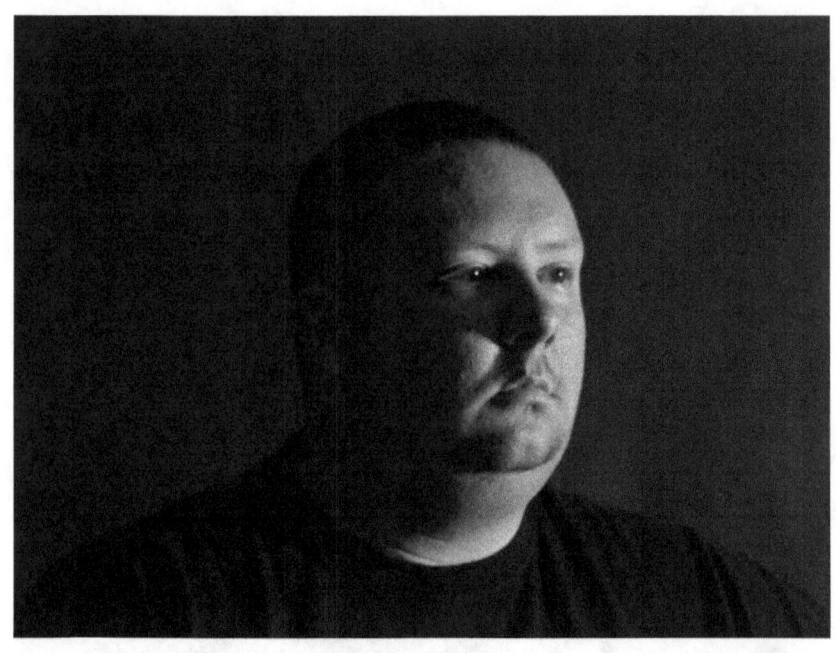

Greg – Army and Air Force – Military Police and Combat Arms – Enduring Freedom and Iraqi Freedom

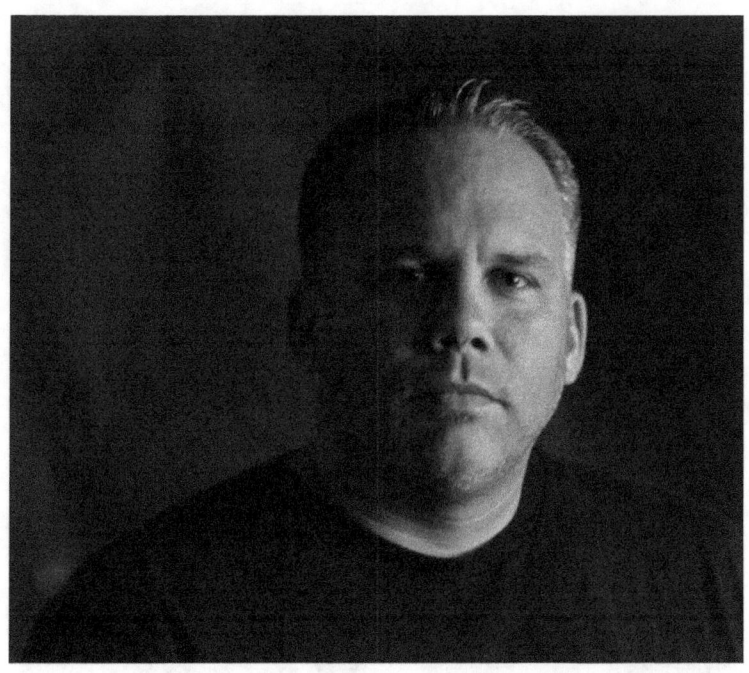

Chris – Air Force – Security Forces – Enduring Freedom and Iraqi Freedom

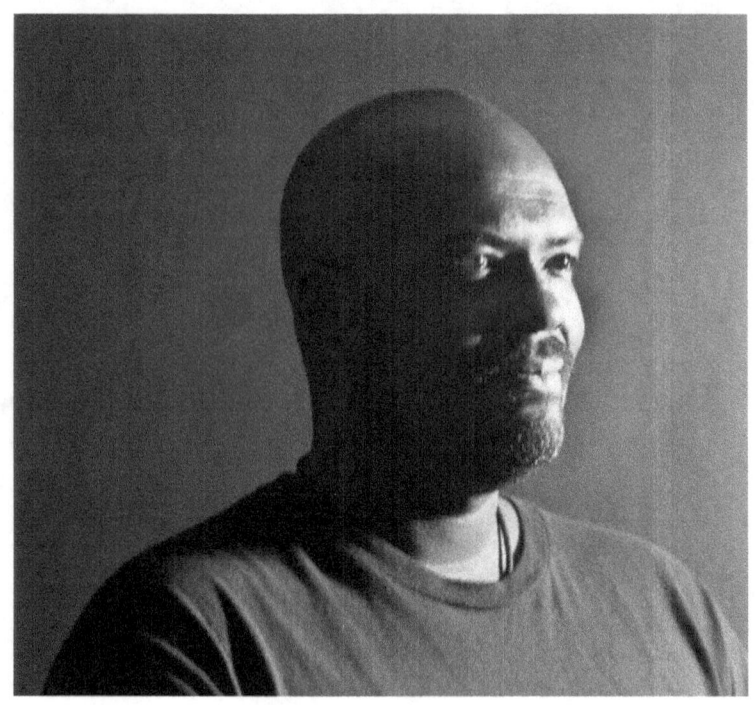

Herb – Air Force – Security Forces – Cold War, Desert Storm, Enduring Freedom, Iraqi Freedom

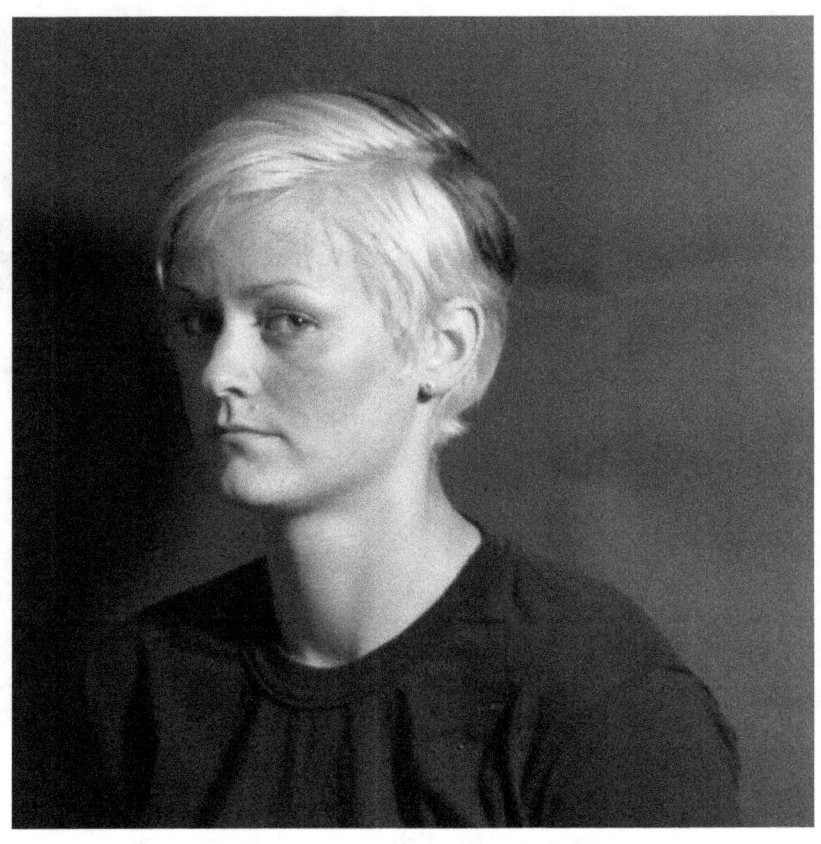

Jessica – Air Force – Combat Arms & Security Forces

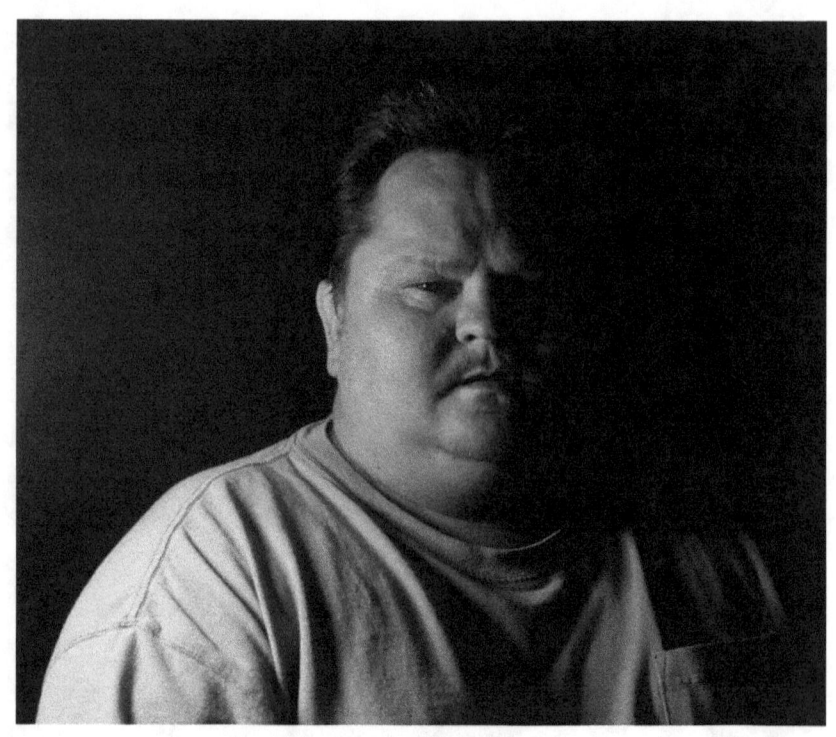

Joel – Army – Airborne – Germany

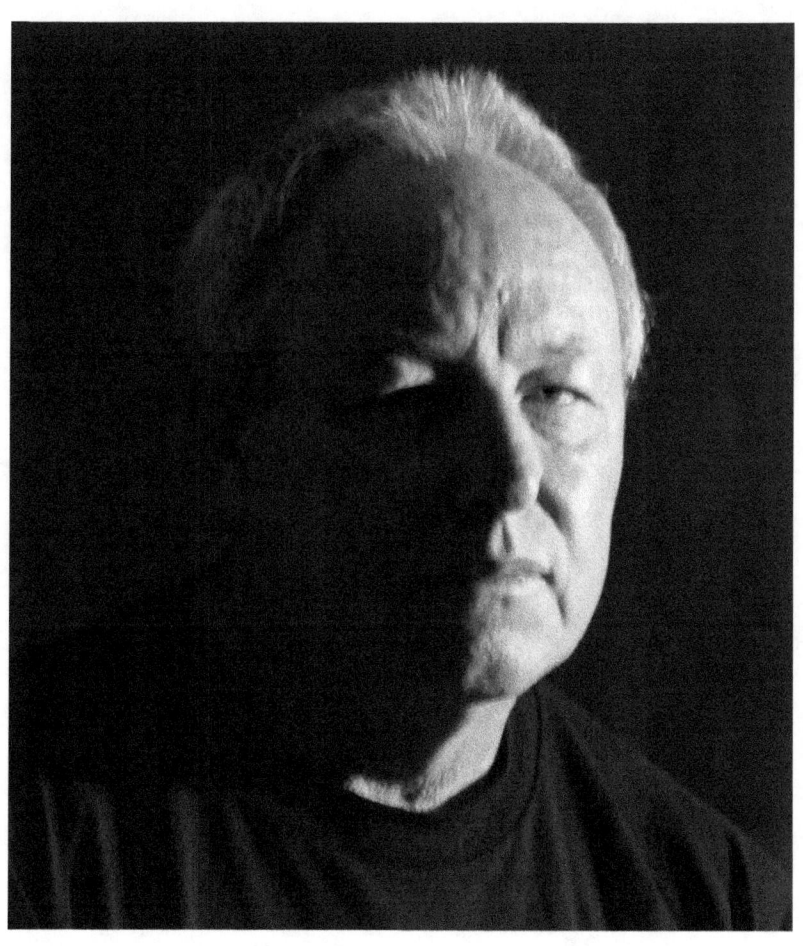

Johnie – Navy – Radioman – Cold War

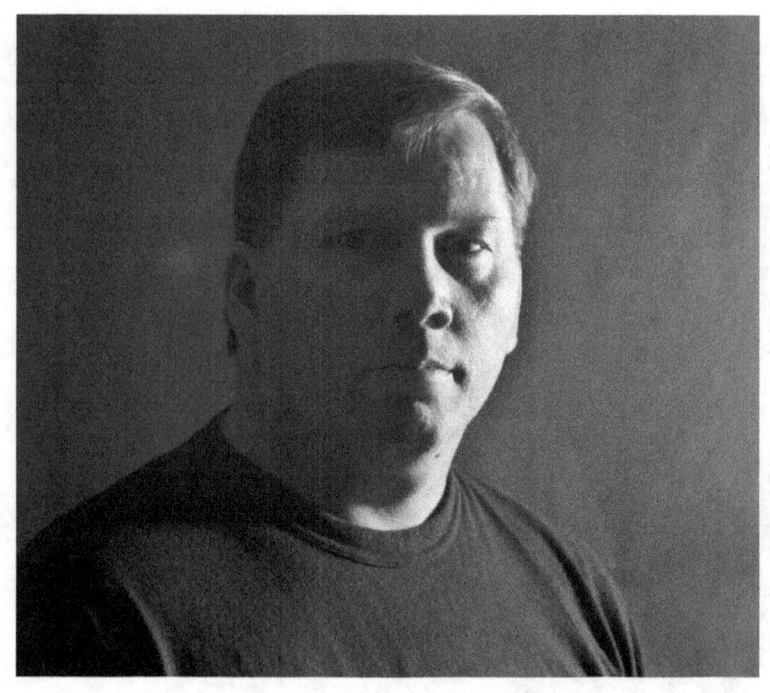

Kevyn – Army/Air Force – Security Forces/Combat Arms – Desert Storm

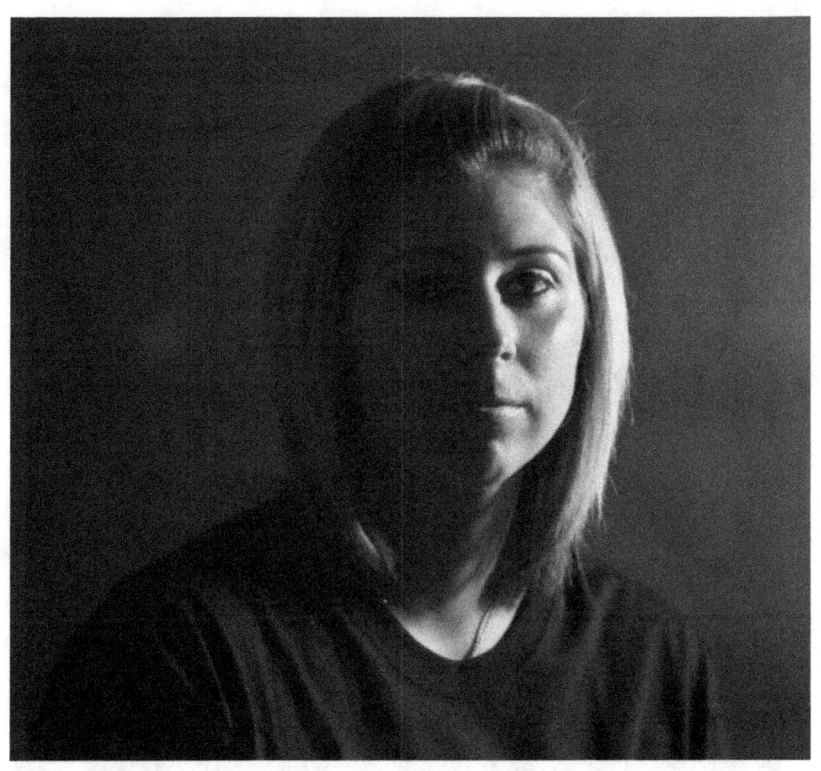

Kim – Air Force – Security Forces – Iraqi Freedom

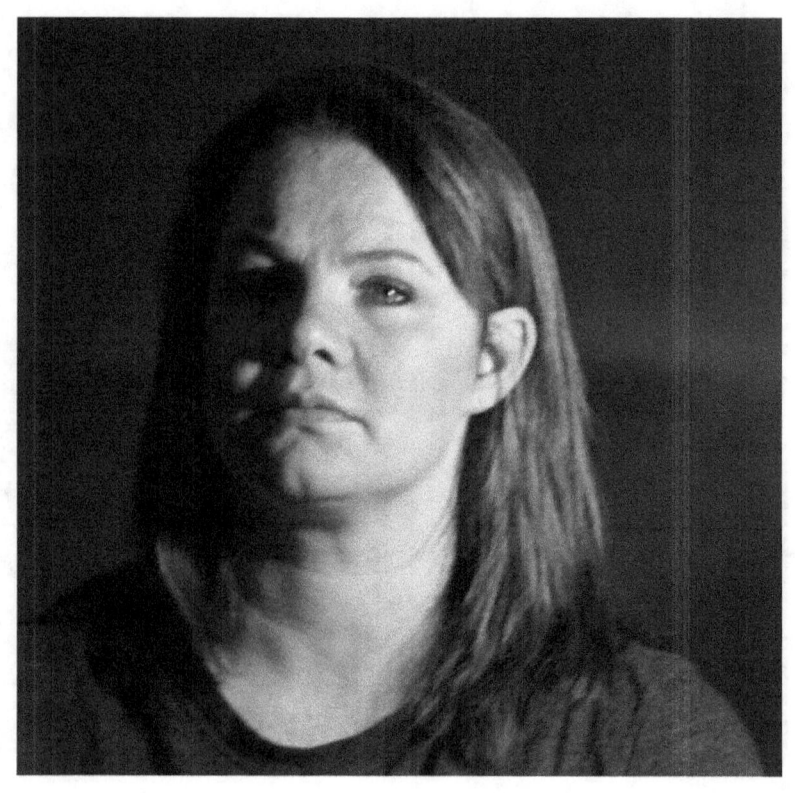

Krystal – Air Force – Security Forces – Enduring Freedom

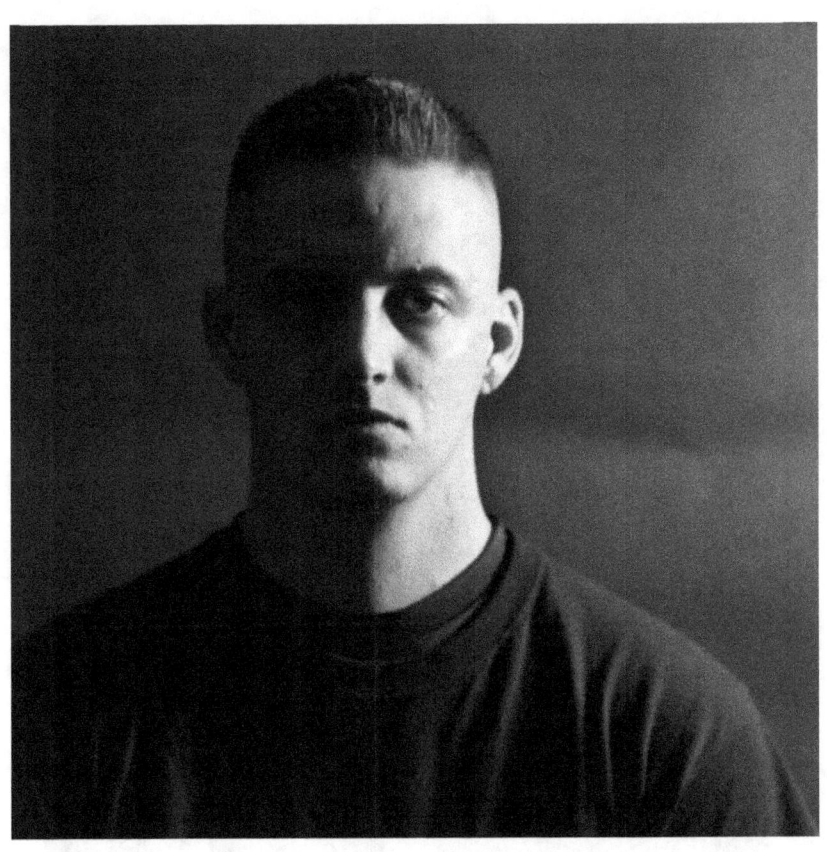

Kyle – Army – Supply Specialist – Iraqi Freedom

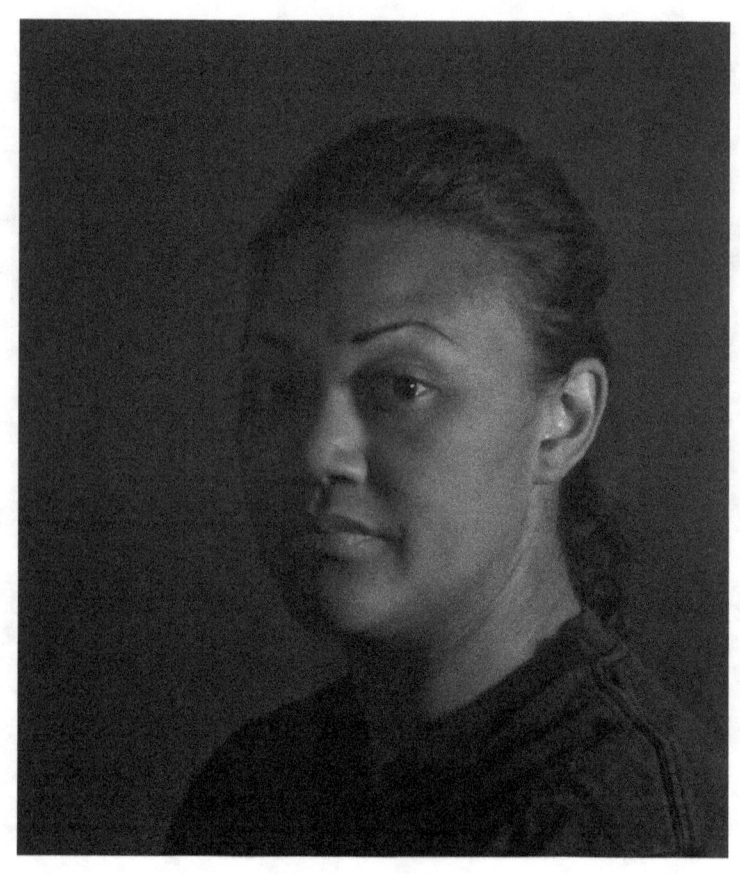

Lan – Air Force – Security Forces – Enduring Freedom

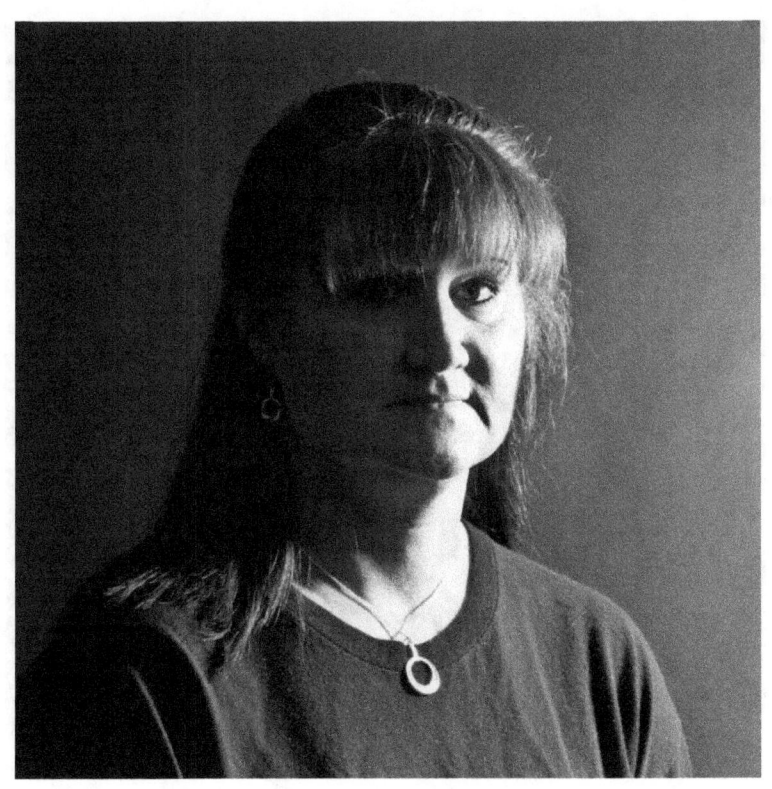

Laura – Air Force – Diet Therapy

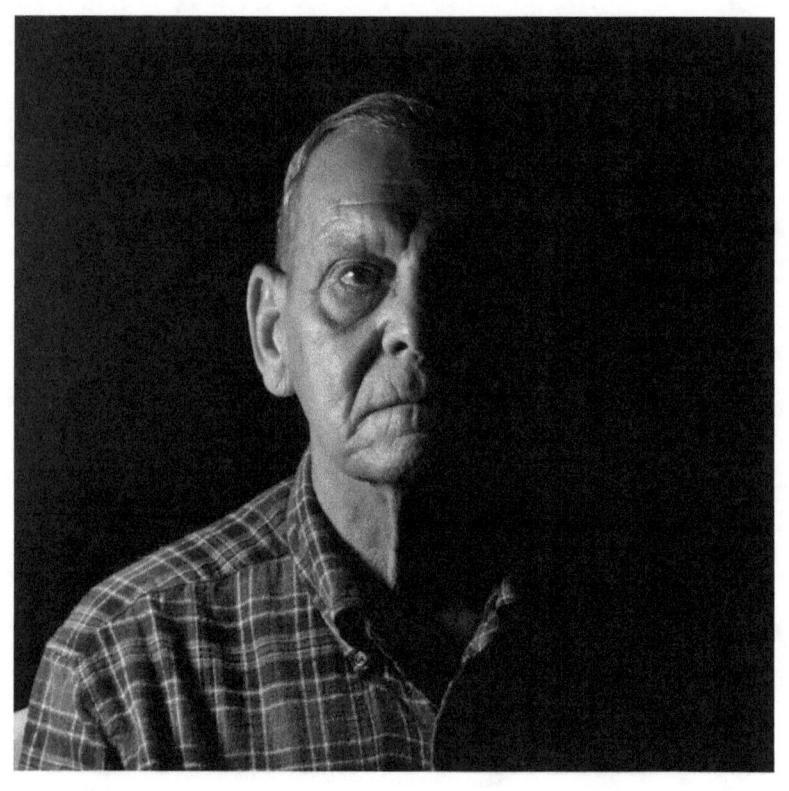

Lee – Navy – Flight Engineer – Vietnam, Bay of Pigs, Suez Canal

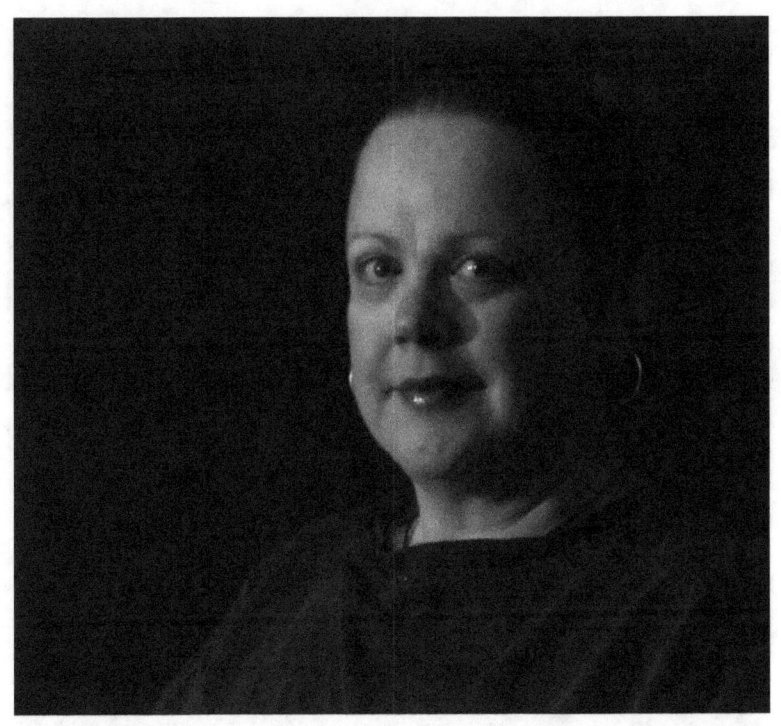

Lise – Air Force – Medic – Cold War, Desert Storm

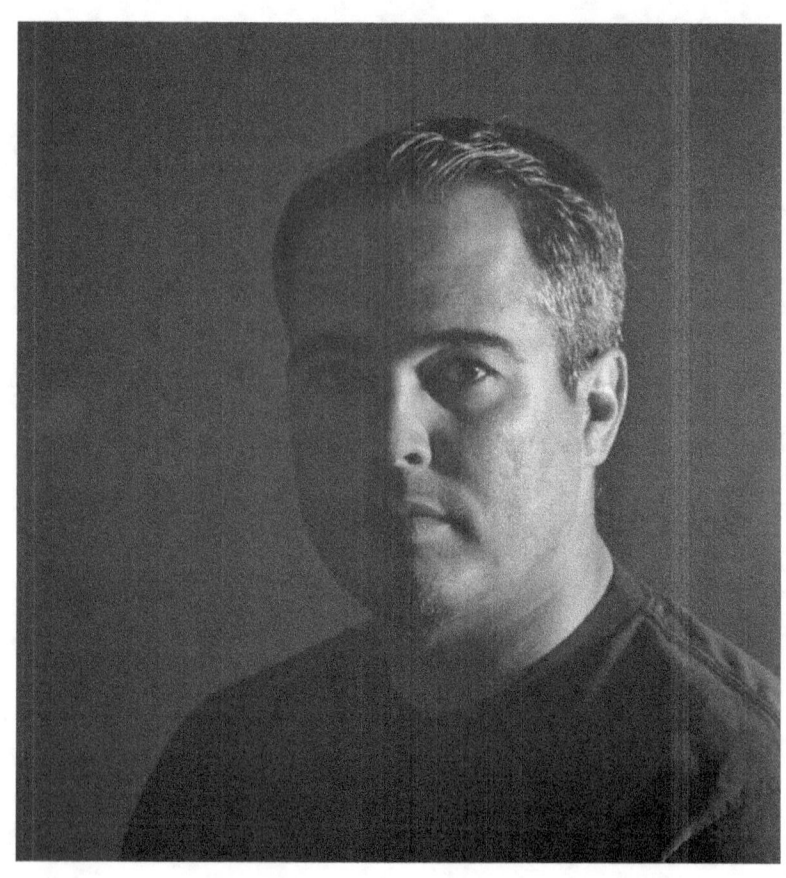

Luis – Air Force – Security Forces – Enduring Freedom, Iraqi Freedom

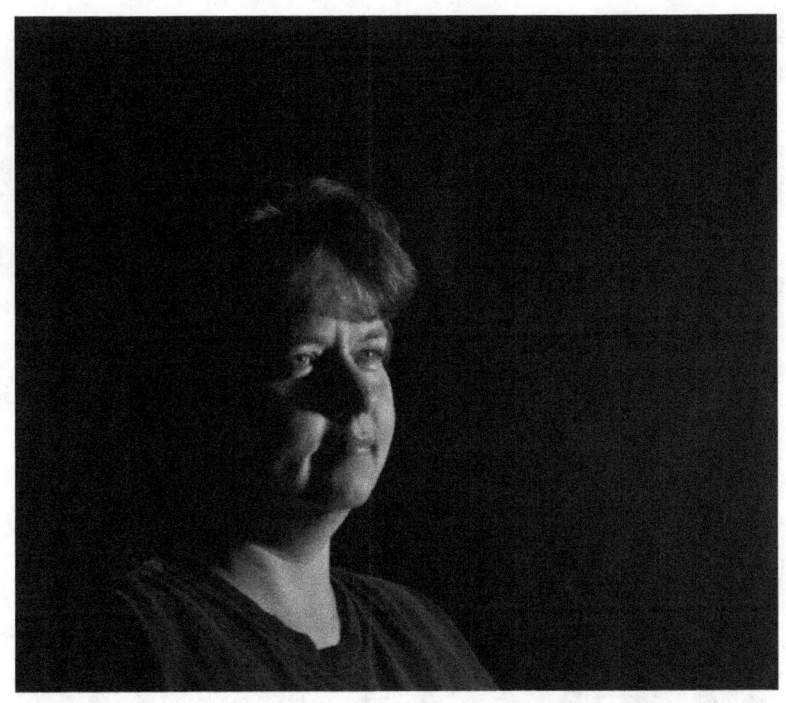

Margaret – Air Force – Passenger and Baggage Clerk – Cold War

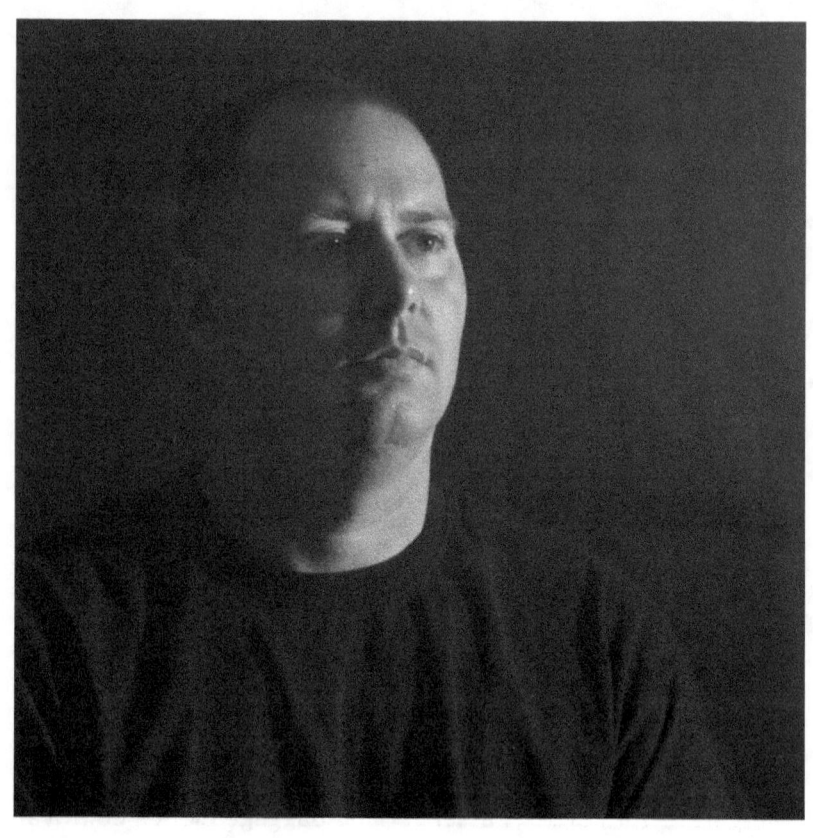

Mark – Air Force – Security Forces – Enduring Freedom and Iraqi Freedom

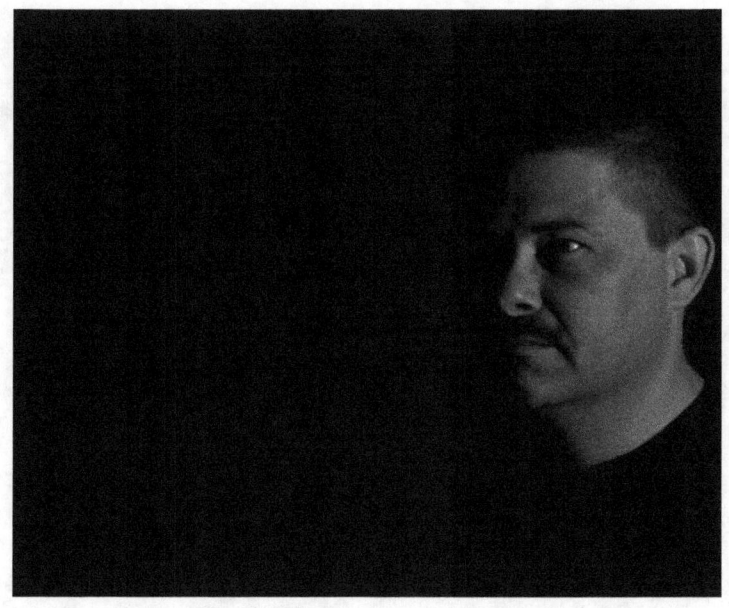

Mark – Air Force – Security Forces – Cold War and Desert Storm

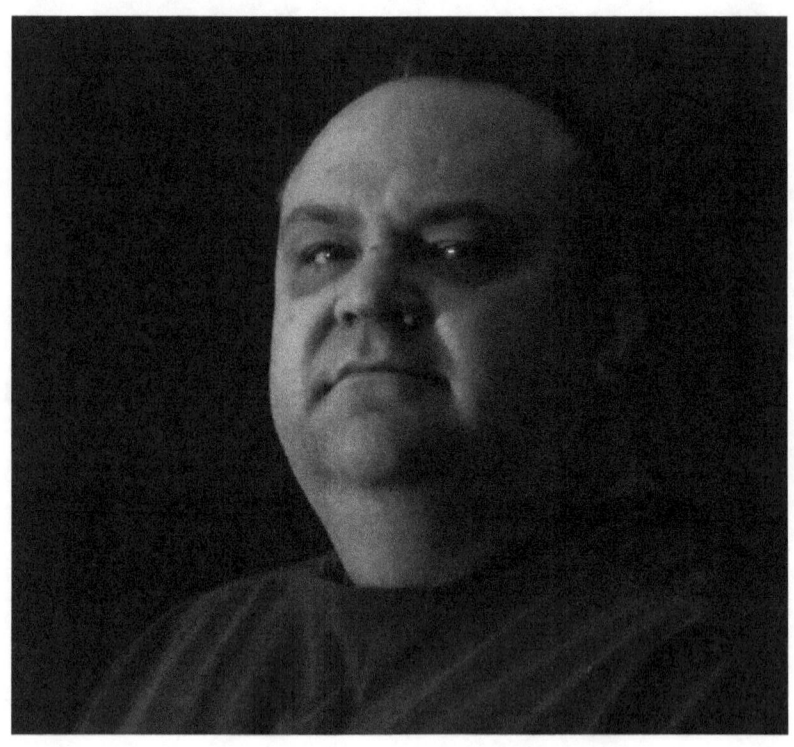

Russel – Air Force – Security Forces/Combat Arms – Cold War, Desert Storm, Enduring Freedom, and Iraqi Freedom

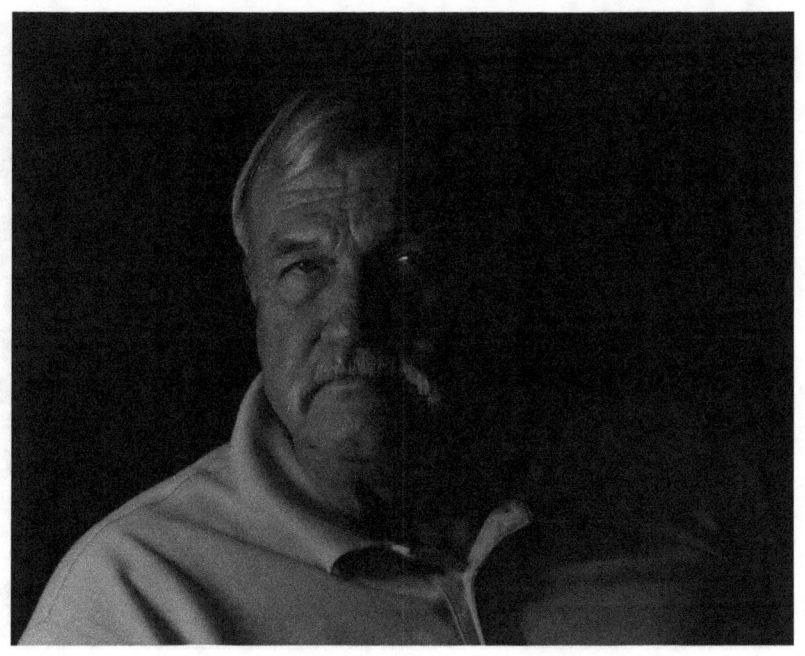

Michael – Air Force – Mechanic – Vietnam

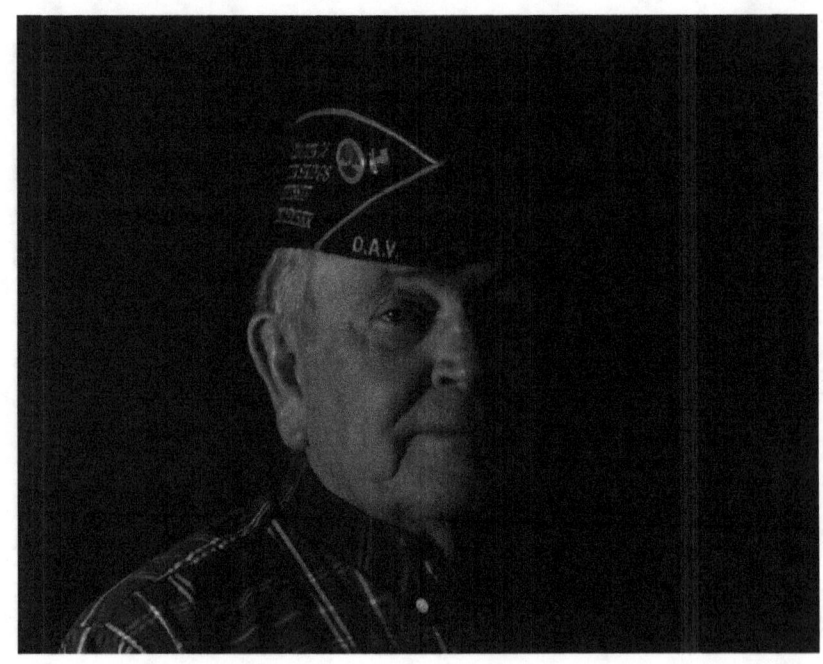

Omer – Air Force – Flight Engineer – Vietnam

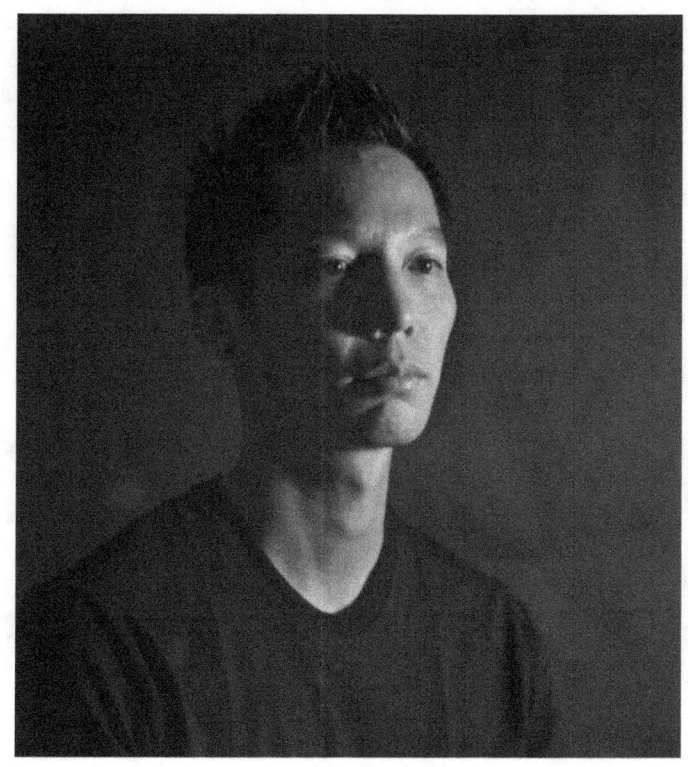

Phil – Air Force – Security Forces – Enduring Freedom, Iraqi Freedom

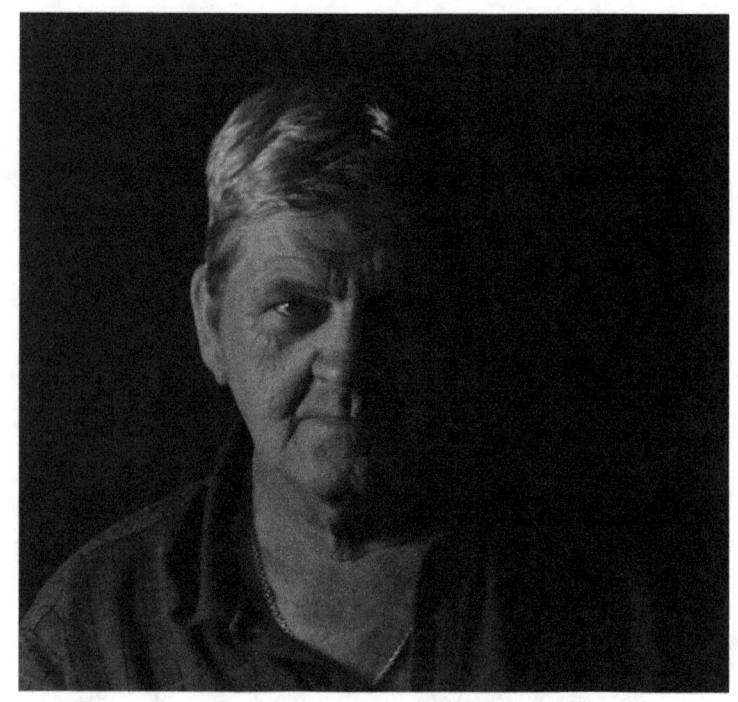

Ralph – Army – Transportation – Vietnam

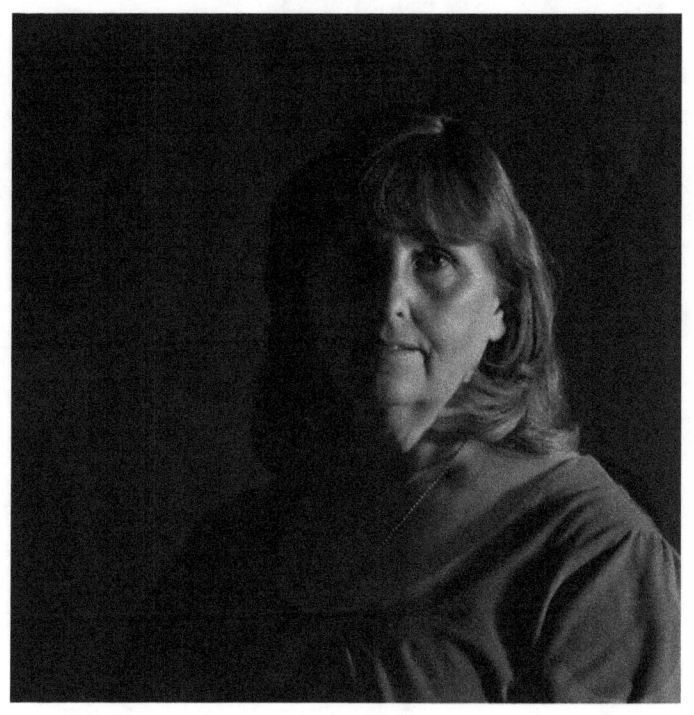

Susan – Army – Truck Driver – Cold War

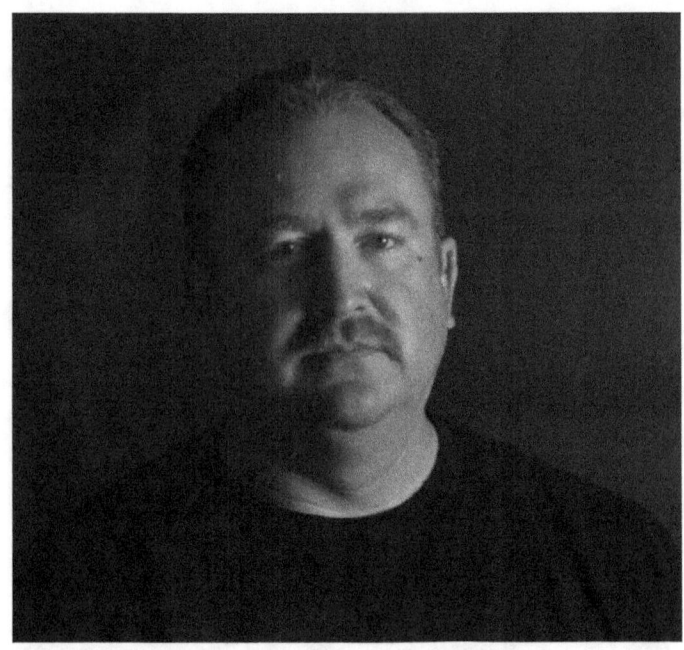

Chuck – Air Force – Security Forces – Cold War, Desert Storm

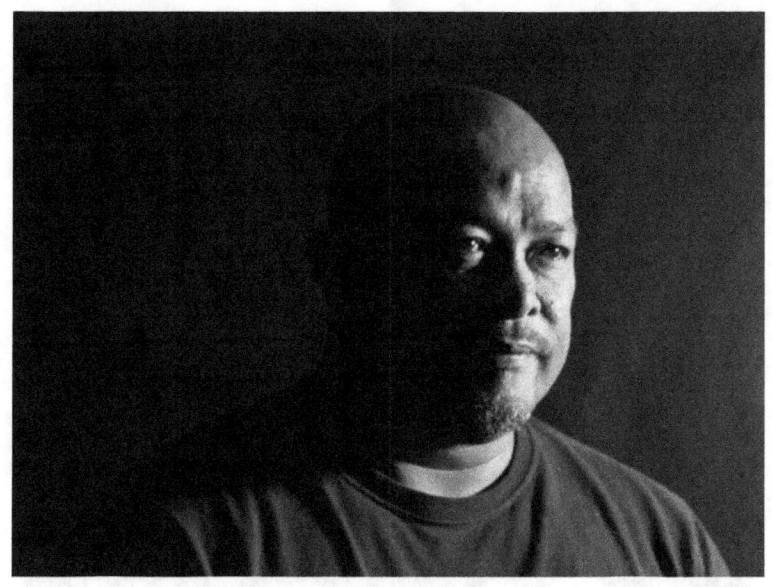

Wayne – Navy – Legal Man – Desert Storm, Enduring Freedom, Iraqi Freedom

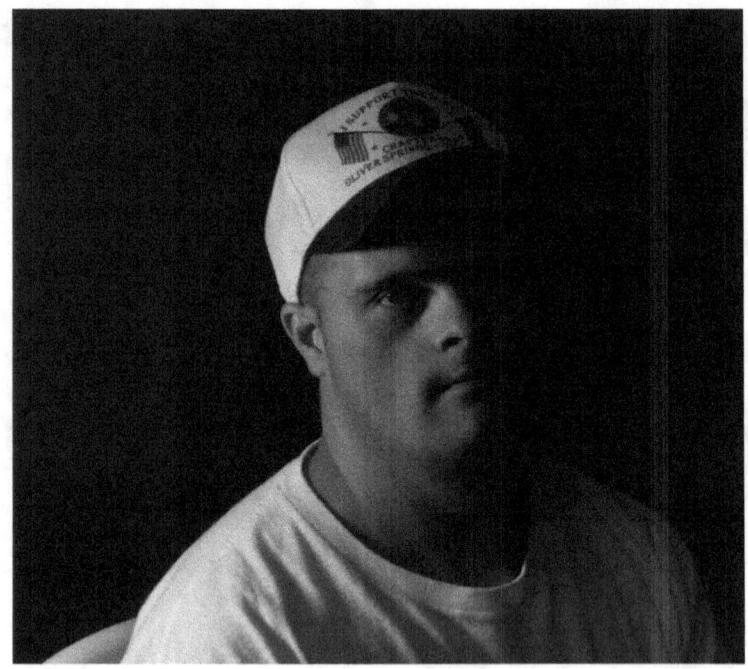

Andy – Warrior at Heart – Not all warriors are veterans. There are those who serve behind the lines and on the home front. Andy stands to represent all those who support our warriors. He has faithfully served the Oliver Springs, TN chapter of the Disabled American Veterans for nine years and counting. Thank you to Andy and to all those he represents.

www.ingramcontent.com/pod-product-compliance
Lightning Source LLC
Chambersburg PA
CBHW072228170526
45158CB00002BA/800